THE FLAG
in American
Indian Art

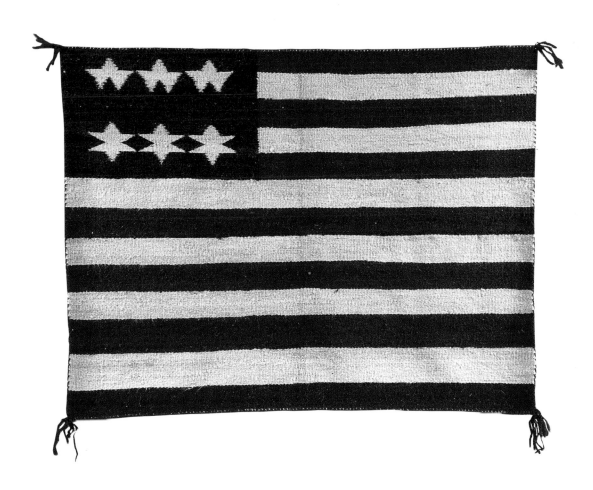

THE FLAG

in American
Indian Art

by Toby Herbst
and Joel Kopp

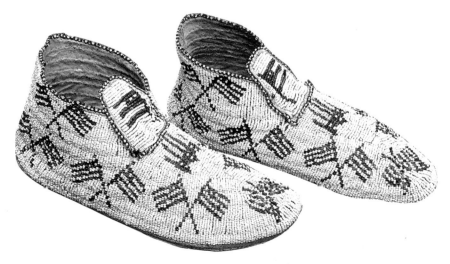

NEW YORK STATE
HISTORICAL ASSOCIATION

UNIVERSITY OF
WASHINGTON PRESS

THE FLAG IN AMERICAN INDIAN ART
was produced by Perpetua Press, Los Angeles
Edited by Letitia Burns O'Connor
Designed by Dana Levy
Printed and bound by South Sea International Press, Hong Kong

Distributed by University of Washington Press

ISBN: 0-295-97313-7 (cloth)
ISBN: 0-295-97314-5 (paper)

All objects in the catalogue were photographed by Steve Tague
with the exception of the following:

Figs. 1, 10 courtesy Milwaukee Public Museum; Figs. 2, 3 from
The Sioux of the Rosebud: A History In Pictures, by Henry W.
Hamilton and Jean Tyree Hamilton. Copyright © 1971 by the
University of Oklahoma Press; Figs. 4, 5, 6, 7 from *A Pictographic
History of the Oglala Sioux, Drawings by Amos Bad Heart* Bull, by
Helen H. Blish. Copyright © 1967 by the University of Nebraska
Press; Fig. 8 courtesy Denver Public Library; Fig. 9 courtesy
Amon Carter Museum, Fort Worth, Texas; Fig. 11 courtesy Thaw
Collection; Fig. 12 courtesy Kopp Collection; Fig. 13 courtesy
Smithsonian Institution; Plate 103-107 courtesy Kopp Collection;
Plate 109 and 119 courtesy Morning Star Gallery; Plate 110 and
121 by Richard L. Faller.

Front cover: Horse Mask, Plate 119.
Thaw collection

Back cover: Girl's Dress, Plate 73.
Kopp collection

CONTENTS

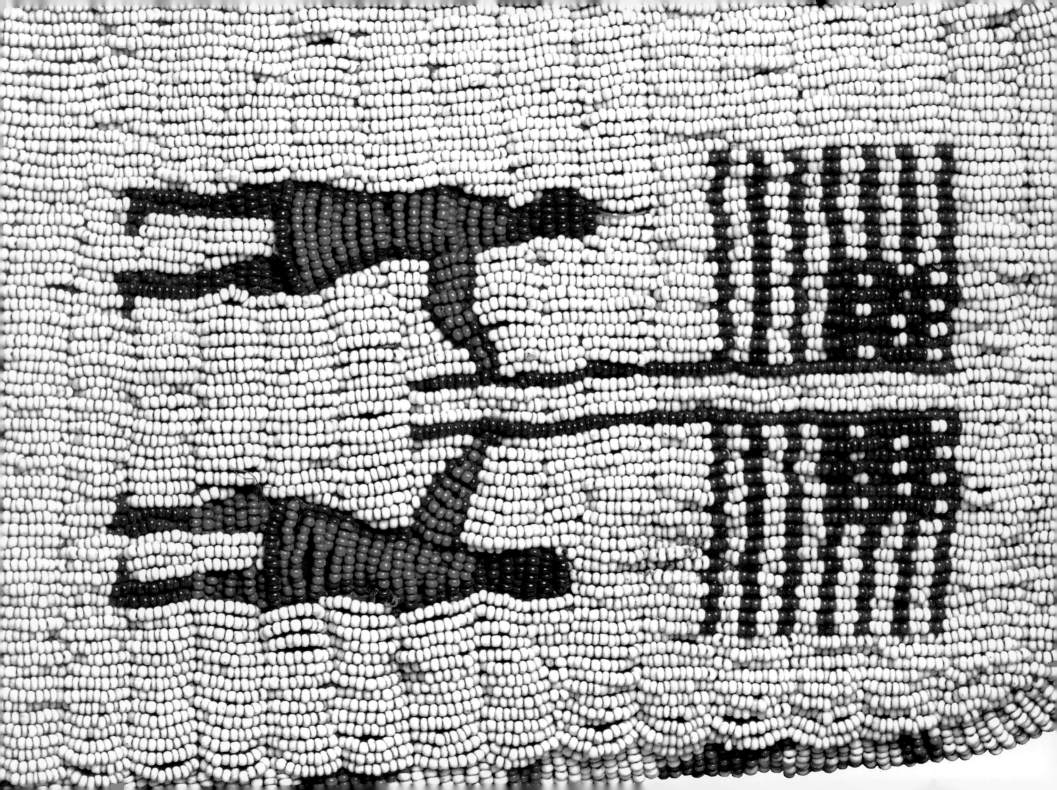

FOREWORD

THE FLAG IN AMERICAN INDIAN ART is the first publication by the New York State Historical Association to be concerned exclusively with objects made by American Indians. Although the Association has published a scholarly quarterly, *New York History*, since 1919; various catalogues of the collection since 1937; and a popular magazine, *Heritage*, since 1985, the subject matter of this catalogue is a new direction. The change has been brought about by the generous gift by Clare and Eugene Thaw of their American Indian collection. A new wing to house this exciting collection is currently being added to Fenimore House, the repository of the Association's major holdings of folk art and nineteenth-century American paintings. More than 500 objects from the Thaw collection will be on permanent view in a gallery and open storage facility. Two additional spaces, a large central hall and a second gallery for changing exhibitions, as well as an auditorium are also planned. With the Thaw Collection and the new gallery facilities, the New York State Historical Association will become a center for the study of American Indian art.

The Flag in American Indian Art includes fifty-four examples from the Thaw Collection and sixty-seven lent by Kate and Joel Kopp. The two collections form the most extensive assemblage of images of the American flag in American Indian art. They include the work of more than two dozen different peoples, from the Iroquois of the Northeast to the Makah of Neah Bay at the entrance to Puget Sound, from the Navajo in the Southwest to the Athapaskan of Alaska. When seen together, the objects present a multitude of different forms, uses, construction techniques, and design. Depictions of the American flag vary from close facsimiles to near abstractions.

As an introduction to this exhibition and catalogue, two essays explain the intriguing background of these colorful objects. Howard Bad Hand gives an insightful reminiscence on the meaning of the American flag within his Lakota heritage. In "The Grandfather's Flag" Toby Herbst, an anthropologist who is now a private dealer in Santa Fe, establishes a relationship between the American flag and the traditional Sun Dance and the Fourth of July celebrations among the Plains peoples around the turn of the century, and Joel Kopp, a long-time folk art

dealer who was inspired to collect American Indian art through qualities of design and craftsmanship, continues the history of flag imagery from other areas.

The American flag motif has often been thought to represent a non-Indian element in American Indian art, one reserved for a tourist audience. The many and varied objects included in this catalogue and discussed in the essays show instead that over the last hundred years or more the American flag touched several layers of many different Indian cultures as these people struggled to adapt to or to accommodate the overriding culture of the United States. The objects clearly share a sense of extraordinary beauty and noteworthy craftsmanship; understanding the context within which they were produced generates even greater respect for the inventiveness and vitality of the different Indian cultures. It is both edifying and rewarding to bring this first catalogue to reality.

GILBERT T. VINCENT

Introduction

PSYCHIATRISTS, I BELIEVE have something to say about the trait of compulsive collecting. Nevertheless, I readily confess to living with that ailment for most of my life. Until my wife and I moved to Santa Fe, New Mexico, master drawings had held us in thrall, along with all kinds of small sculptures and *objets de vertu*. But in Santa Fe, we sensed a new enthusiasm, for here was the center of the market for American Indian works of art.

By chance, my wife Clare spotted an attractive square of hide embroidered with beads depicting flowers and American flags (pl. 101). After we owned it, we learned that it was Athapaskan (from the Alaska-Canada border area) and discovered that it was included and reproduced in the now-famous exhibition "The American Indian: The American Flag" prepared by Richard Pohrt for the 1976 Bicentennial Celebration.

We were then off and running, trying to find other Native American works of art incorporating flags. I became known in the trade as "the flag man," and with the help of some of the best Indian art dealers, particularly Mac Grimmer of the Morning Star Gallery, we assembled a considerable and varied group.

Later, I heard about friendly rivals, Joel and Kate Kopp, who were forming a similar collection, and more recently, we decided to join forces to create this flag exhibition. Both the Thaws and the Kopps now have in different ways pursued far more extensive goals in collecting American Indian art of all geographic areas, but we still feel strongly about the aesthetic qualities of this group and about the underlying significance and cultural meanings that Howard Bad Hand and Toby Herbst reveal with such original insights in their essays. We hope that this exhibition and its illustrated catalogue will carry one step further the scholarly study and the growing public appreciation of our superb Native American artistic tradition.

EUGENE VICTOR THAW

ACKNOWLEDGMENTS

Many friends and colleagues have been extremely generous with their time and the benefit of their knowledge and experience. In several cases, they have challenged and disagreed with our conclusions with honesty and candor and made useful suggestions.

Very special thanks, therefore, go to Eugene V. Thaw, Gilbert Vincent, Dennis and Rosemary Lessard, Ralph T. Coe, Dr. David W. Penney, Dr. William K. Powers, Danielle Foster-Herbst, and Kate Kopp.

We would also like to thank Howard Bad Hand, Kay Carlson, Robert Vandenberg, Joe Rivera, Mark E. Hooper, David Wooley, Jonathan Holstein, David Burns, Michael O'Connell, Candace Browne, and Tom Cuff for their encouragement.

THE AMERICAN FLAG IN LAKOTA TRADITION

by Howard Bad Hand

I SPENT MY CHILDHOOD on the Rosebud Reservation of the Sioux people in South Dakota. Born into the Bad Hand family of singers known as Red Leaf, I participated freely in the traditions maintained by our family and the Sicangu (Brulé) people. Continuing to participate in our culture as well as other native cultures has given me the personal joy of watching and pondering the many changes our people have gone through.

Early in my youth I danced the currently popular style of grass dancing. In dancing I was able to participate in many gatherings, celebrations, and exercises of spiritual rituals. So I was also given the opportunities to change—along with the people—in dress, material culture, fashions, fads, and fancies. Today the Lakota people, along with the dominant American culture, differentiate art from the rest of the material culture. But in the traditional Lakota view that I learned as I grew up, art was not distinguished from the practical use of materials in the culture, because the material culture of the Lakota was an integrated expression of beauty. Many symbols, forms, and materials of beauty were introduced spontaneously by the practice of the traditonal culture, but many other symbols, forms, and materials were adopted and adapted to the Lakota culture from other sources.

The material culture of the Lakota is most evident in the daily life of the people and in the practice of such traditions as the gathering of families and friends to celebrate social achievements, military or warrior recognition, memorials, and the practice of spiritual ritual and ceremony. Today any visitor to a Lakota gathering will be struck by what appears to be a zealous showing of patriotism and love for the American flag and its many symbolic variations. The American flag is a symbol of another culture and people that the Lakota has adopted and adapted to practical use. Of course, this raises the question, "why?"

Throughout history many atrocities, injustices, and destructive aggression were committed against the Lakota by the United States and the American people. The Lakota were forceful in the defense of their sovereignty, even fighting the U.S. to a standstill in battle. The Lakota were finally seduced, forced into and relegated to reservations in the late 1880s. During this time the American flag started to appear in Lakota art and design in clothing and regalia.

The Lakota in their relation to the United States and other governments still have a sense of sovereignty about their being—and probably always will. Being a large tribe, extremely tribalistic or nationalistic, and having a legal status of "dependent nation" to the United States, the Lakota hold and maintain a dynamic, vibrant culture. Yet as a people, the reality of subjugation is hard upon them. History shows that a conquered people will adapt something, a symbol or some material representation, from their captors to maintain a sense of being or identity that helps them survive. I believe the Lakota people adopted the American flag as such a symbol because within Lakota culture, the flag carries a far different meaning than that of patriotism.

From a pure art viewpoint, especially the Lakota view, individual artistic design is free to draw upon many sources both mystical and practical. Yet, to symbolize ideas and thoughts into images, the Lakota initially drew upon simple geometric symbols and designs to denote the human experience, history, stories, and meaning of life. In the flag, the Lakota saw visual simplicity and an attractive pattern in the simple red and white stripes and blue square with stars. It was easily adapted because this symbol was easy to copy and it was readily utilized, especially in light of the Lakota's relationship to American culture and the need of the people to survive.

In war times, flags captured by the Lakota were used as prizes of war. Some were donned as clothing to show off the prize, symbolic of bravery and glory. Many geometric configurations of the flag crept into the material culture and were expressed artistically in many mediums, especially in beadwork, quiltwork, porcupine quillwork, carvings, clothing and dance regalia, and present art expression in its many mediums. The flag enjoys widespread utilization as a symbol to show beauty and attractiveness, lend meaning to the warrior tradition, and more importantly, as a reminder of the relationship between the Lakota and American people.

Today when the flag symbol appears on clothing and regalia, it often indicates that the wearer has served in the U.S. Armed Forces, or it honors a parent, friend, or relative in the Armed Forces. After all, presently the Lakota can only enjoy its warrior tradition legally by serving as a soldier for the United States. In the Lakota view, the most important function of the warrior is to serve and protect the people, a concept that seems to have been broadened and adapted to mean service to the land and protection of the "nation." Wearing of the flag symbol and its facsimiles serves as a reminder of that service.

When I participate in traditional Lakota celebrations, I am struck by the number of flags utilized. Though the individual expression of patriotism is allowed in the Lakota culture, I see a very different reason for the utilization of those flags than patriotism for the United States. Each flag that is flown at a celebration is identified by name with the warrior/soldier who earned it. At the end of a military career or if one falls in battle, soldiers are given an American flag in recognition of their service. To the Lakota, a traditional warrior culture, this gift of the flag is highly prized. In former times, an eagle feather was given for acts and deeds of honor, bravery, and valor; coup sticks were carried by warriors to record how many times they could strike and humiliate their enemies without killing them. Since these traditions are rarely practiced today, the Ameri-

can flag has replaced them as the symbol of carrying on the warrior tradition. Through the flag, the individual warrior is honored, recognized, and memorialized; it symbolizes the prowess of the individual warrior, not patriotism.

The flag has been incorporated into the warrior songs of the Lakota. Although the lyrics sound patriotic, the emphasis is on the words of a warrior speaking to the people about his soldier experience. In the Lakota language, metaphors, cryptic imagery, and context indicate which of many potential meanings is intended for a given situation, so one word can be utilized and its various meanings specified by the context of the subject. For instance, *Tunkasila yapi* is literally rendered, "The One they call Grandfather," but it is transcribed in one song as "The President." *Tawapaha ki* is a term that denotes one's own staff, which is used to defend oneself or to point threateningly at another. In the song the American flag is referred to as "the staff of the one they call Grandfather," words the warrior uses to tell of his soldier experience.

The following are four examples of flag songs, national anthems, and a victory song, which are used in the song traditions of the warriors:

National Anthems or Flag Songs

1) Tunkasila yapi tawapaha kihan oihanke sni he nanji kte lo. Iyohlateya oyate kihan wicicagin kta ca lecamun welo.
The President's flag will stand without end. Under it, the people will grow, therefore I do this.

2) Tunkasila yapi tawapaha ki kowakata nanji yelo. Lakota Hoksila kola lena ecunpelo.
The President's flag is standing across the seas. The Lakota boys, my friend, have done these things.

3) Tunkasila yapi tawapaha ki maka ihankesni hehan nanji ktelo. Iyohlateya oyate kihan wicicagin kta ca hecamun welo.
The President's flag will stand in a world without end. Under it, the people will grow, therefore I have done those (things).

Victory Song

1) Tunkasila yapi tawapaha ki iyuskinyan icu wo eyaca he iwacu. Heun etan wacipi ki le micu.
The President said (to me), "Take this flag joyfully, so I took it." From that time on, he has returned this dance to me.

The Lakota view of reality currently is spiritual based, so a movement is occurring toward the rebalancing of the culture. The Lakota are very aware of their relationship to the United States, and though anti-Americanism does exist, it gives way to a worse relationship of dependency between the two, and perhaps by creating bridges of understanding between the two as well as others, we may find once again a world of balance.

My prayer is that by sharing knowledge with each other and understanding of each other, we can let each other be. May your understanding and my words move us toward peace!

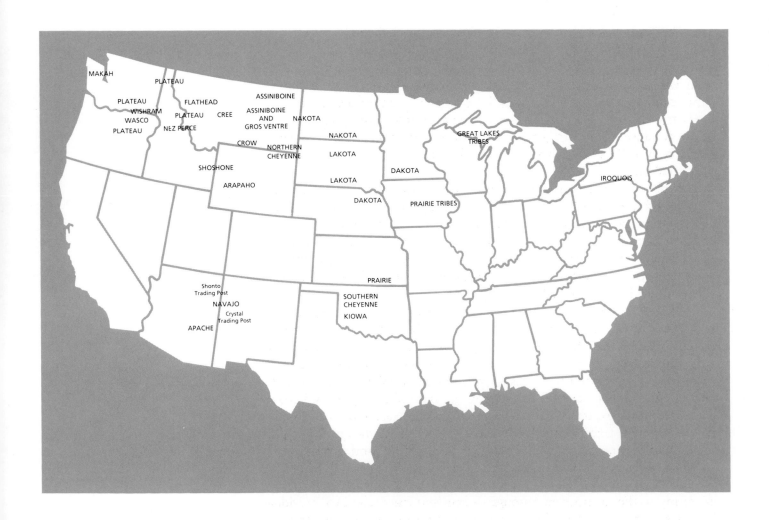

Tribes and locations associated with
objects illustrated in the catalogue.

The Grandfather's Flag

by Toby Herbst and Joel Kopp

THIS ESSAY IS ENTITLED "The Grandfather's Flag" because, as Howard P. Bad Hand explains in his essay, it is one of the terms used by the Lakota to denote the American flag. This essay will set forth some of the historical and cultural reasons why the American flag became such a pervasive design element in the art and artifacts of Native Americans in the period covering roughly 1880 to 1910. Because the vast majority of American flag imagery comes from the Lakota or Western Sioux, this essay focuses on the art and history of the Lakota.[1]

It has always seemed curious and contradictory that Native Americans who fought so valiantly and tenaciously against the encroachment of the United States should use the symbol of that government to decorate their clothing and belongings during the early years of their confinement on reservations. This essay suggests a number of theories to explain why the symbol of their oppressor was not only palatable to them but, in fact, embraced by them.

Native Americans were never a homogeneous nation. In what is now the continental United States and Canada there were hundreds of tribes divided into different language groups, each of which had distinct and complex social structures of laws, customs, mores, religious beliefs, and rituals. The tribal differences are manifested visually in the way each of these groups lived and dressed and in the symbols, designs, and colors each used in its art, its functional and religious objects, and its clothing. In societies that traditionally had no written language, the continuity of the cultural heritage is dependent upon visual symbols and narrative arts — storytelling, songs, and oral history. The important symbols in Native American cultures are connected to the earth, sky, and water and their life forms, to the supernatural through dreams and visions, and to individual histories, so the American flag is an odd element in this iconography.

By the end of the eighteenth or the early nineteenth century most Native Americans of North America were familiar with European and American banners and flags and the political interests they represented. For example, during the War of 1812 Tamahay, a Dakota or Eastern Sioux, saved the American flag from being burned by British troops at Fort McKay. The Lakota understanding of the concept of flags as symbols of political power is demonstrated by American Horse's winter

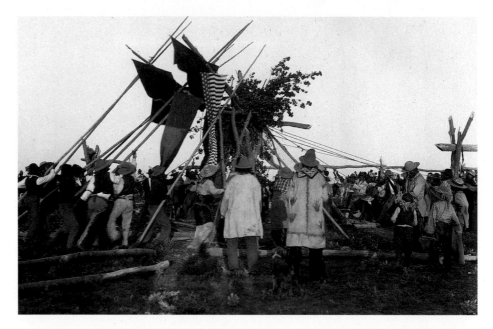

Figure 1. Fort Belknap Indian Reservation, Montana, July, 1905 or 1906
Sumner W. Matteson

The Sun Dance Pole is being erected in the center of the "Lodge" or Dance Circle. Amercan flag bunting hangs as an offering from one of the forked branches at the top of the pole, clearly illustrating a relationship between the Sun Dance and the American flag at the turn of the century.

count drawing (a pictographic calendar) for 1874–75, which depicts the October 1874 destruction of the American flag and pole that had been erected at Red Cloud Agency against the wishes of Red Cloud and other chiefs.[2] The Lakota recognized that the flag was a political symbol that, if imposed on an unwilling populace, represented dominance and oppression and so should be quickly and forcibly removed.

Native Americans also understood that flags had the power to protect those who displayed them.[3] They knew that because flags were symbols of political power they represented the protection of that power, though this concept was often contradicted by their experience. For instance, at the 1864 Sand Creek massacre in Colorado, Black Kettle's band of Cheyenne was attacked by the Colorado cavalry but did not wish to fight. To show this intention Black Kettle raised the American flag and the white truce flag[4] which were disregarded by the troops, and the Cheyenne slaughtered. Before the massacre at Wounded Knee, Big Foot, leading his band of Mineconjou Lakota to Pine Ridge to surrender, was intercepted by a detachment of the Seventh Cavalry. While under the troops' guns, Big Foot raised a white flag "as a sign of peace and a guarantee of safety."[5] The disastrous result is well known.

The Native American belief in the protective power of the flag was probably one reason why American flag imagery proliferated in Lakota crafts between 1880 and 1900.[6] By covering objects of clothing and personal possessions with images of the American flag wrought in quillwork or beadwork, the Lakota identified, or appeared to identify, with the United States. John Anderson's photographs of Lakota war dances on the Rosebud Reservation between 1889 and 1893 show men dancing around two American flags (fig. 2). War dances such as the Omaha or Grass Dance were freestyle and spontaneous. They were often reenactments of actual battle deeds and were performed by warriors who had fought against the U.S., and therefore must have looked menacing to the missionaries, Indian agents, and soldiers. The presence of two flags, as in Anderson's photographs, could be interpreted as a double precaution to identify the dances as nonhostile toward the United States. Similarly, the use of American flags to decorate native belongings, especially clothing, would have identified the owner as an ally of the U.S.

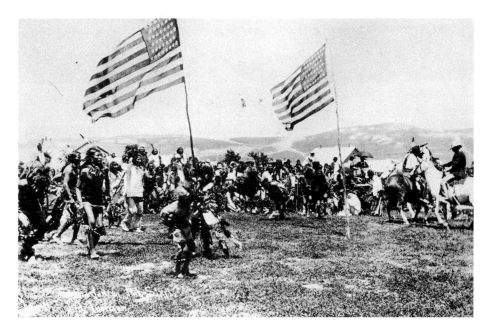

Figure 2. A group of Lakota men perform the Omaha or War Dance on the Rosebud Reservation, South Dakota, 1893
John A. Anderson (1869–1948)

Note the presence of two American flags on the dance field.

and under its protection. It appears that traditional ceremonies, even the ferocious warrior dances, were sanctioned when performed under the flag and on special holidays such as the Fourth of July. Traditional dress and cultural objects emblazoned with American flag designs would be much more acceptable to an intolerant government determined to assimilate native people.

In the nineteenth century the flag was seen by American Indians as a battle emblem that was prominently carried by U.S. troops during military engagements. It flew over forts and settlements, clearly a symbol honored and respected by a strong and powerful enemy. Smaller images of the flag appeared as insignia on U.S. military dress and gear. Flags were also tokens of friendship, often given by the U.S. government at the conclusion of treaty negotiations or presented by politicians on their travels to Native American settlements (fig. *9*). Offered to chiefs and tribal leaders when their delegations visited Washington, they were looked upon by Native Americans as a gift of respect and appeasement, conferring status on the receiver. It is in reference to gifts and the status they conferred in Lakota family histories that flags appear on some Lakota artifacts, such as a child's cradle from the Red Cloud family.[7] Unique flags, such as the stylized and eccentric version of Old Glory presented on the twenty-fifth anniversary of the Battle of Little Big Horn to White Man Runs Him, a surviving Custer scout, were occasionally given as gifts by the U.S. government. Flags captured in battle were believed to contain the power of the enemy, which could then be transferred to its Native American owner. This concept appears to be illustrated in the ledger drawing by the Oglala warrior Sitting Bull (plate 111). Mounted and in full war dress, Sitting Bull holds a coup stick with a flag tied on the end. This association between war and flags can be further illustrated with two sacred war bundles that contain American flags: one, collected from the Winnebago, contained two (of three) flags dating prior to 1845; the other was collected from a Gros Ventre by the name of Curly Head, who had served as an Army scout.[8] Although these flags appear to commemorate the bundle-owner's service in the U.S. military, the fact that they were included in sacred bundles implies that the owners attributed special powers to them as well.

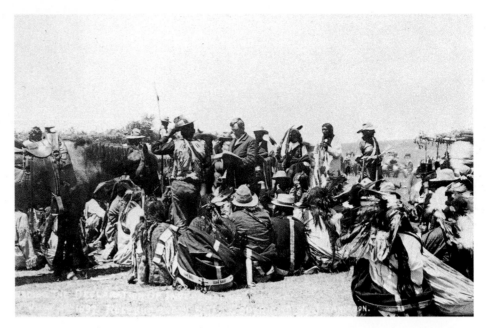

Flags and flag-waving were very popular in America at the end of the nineteenth century, and native peoples were subjected to it at government forts, agencies, schools, as well as patriotic holidays. Flags were used in advertising and labeling on products that reached the reservations, and some Lakota traveled to U.S. cities where the symbol was widespread. Many Lakota, especially from Pine Ridge and Rosebud Reservations, were recruited for Buffalo Bill Cody's Wild West show, where they were exposed to a barrage of American flags. This influence though hard to quantify, cannot be ignored,[9] and must have contributed to the popularity of the symbol in Lakota art.

Many of the objects in this exhibition were made by the Lakota people, especially the Brulé Sioux and the Oglala Sioux subgroups that live on the Rosebud and Pine Ridge Reservations in South Dakota. Most of the seventy-eight pieces of Lakota beadwork show evidence of wear, implying native use. A number of objects, such as the beaded vest with the name P.C. Voice (Good Voice), a pouch with Henry Bring The Pip[e], and another vest with the initials of Thomas American Horse, bear Lakota names, thus supporting the contention that the Lakota produced artifacts with flag designs for their own use and less for outsiders. Further proof can be seen in photographs taken at the turn of the century on the Rosebud Reservation by John A. Anderson, which show Brulé Sioux men wearing flag-decorated artifacts.[10]

Though the majority of flag-decorated artifacts appear to have been made for native use, flag-imagery beadwork was also offered for sale to outside consumers. The cover photograph for a flyer for L. W. Stilwell (wholesaler of Indian Relics, Bead Work and Baskets, No. 43 Lincoln Avenue, Deadwood, South Dakota) for the season of 1908–9[11] shows the interior of Stilwell's store with patriotic bunting along the ceiling molding. At least two flag pieces can be discerned among the many artifacts for sale.

In his pioneer study, *The American Indian, The American Flag,* Richard Pohrt explains:

> ...[T]he vogue for decorating articles with the flag and other patriotic emblems really started among the Plains Indians during the early reservation

 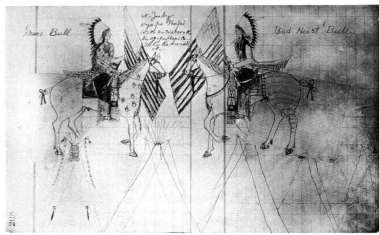

period....during which the traditional life style of the Sioux underwent traumatic changes....Confined within boundaries established by the government, the old ways and values disintegrated under the pressures of reservation life, disease, and poverty. However, the enforced idleness of reservation life allowed the Sioux artists plenty of time to produce the beaded, quilled, painted, and carved objects they so admired....Few other tribes had developed a beadwork tradition as strong and widespread as theirs, for Sioux women were wonderfully skilled and ambitious beadworkers. Family pride was a dominant factor. It was important to make a proper appearance at social functions. The lavish decoration of clothing for prestige was a powerful artistic motive. There was also a desire to have suitable presents to give away to visiting Indians or to take along on travels to other reservations....Their work also found a ready local market on the reservation with traders and store keepers.[12]

These changes in Lakota arts and crafts brought about by the new Reservation life-style reflect much greater changes taking place simultaneously in the traditional fabric of Lakota society.

The "Sun Dance,"[13] a four-day ceremony that takes place during the Cherry Ripening Moon of late June, July, or early August, is the most important social and religious ritual in traditional Lakota life. Different bands of Lakota come together to celebrate this thanksgiving ritual, which fosters group identity, interaction, and cohesiveness. Individuals honor pledges of prayers and sacrifices to benefit all of the Lakota. Because the Sun Dance involves self-torture, is pagan, and fosters native identification, the sacred ritual was officially banned by the U.S. government in 1881, although that ban was not enforced until after the summer of 1883.[14] Other Native American ceremonies and practices such as feasts, dances, polygamy, and shamanic curing were also banned in this decree.[15] This ban was lifted with the Indian Reorganization Act of 1934.

The facts surrounding the origins of the Lakota Fourth of July celebration are obscure. It is assumed that these celebrations were instigated and encouraged by the Bureau of Indian Affairs and were meant in some way to replace the Sun Dance.[16] The first known Lakota Fourth of July celebration was by the Brulés of Rosebud in 1897.[17]

Figure 4 (left). Fourth of July Camp, Pine Ridge Reservation, South Dakota, 1898
Amos Bad Heart Bull (1869–1913)

The form of the Fourth of July ceremonies has been adapted from the traditional Sun Dance circle. An American flag occupies the center of the circle where by tradition the Sun Dance pole would have stood.

Figure 5 (right). Fourth of July Ceremonies, Pine Ridge Reservation, South Dakota, 1898
Amos Bad Heart Bull (1869–1913)

The two "chiefs," an honorary title recognizing their leadership at the Giveaway ceremony, hold American flags.

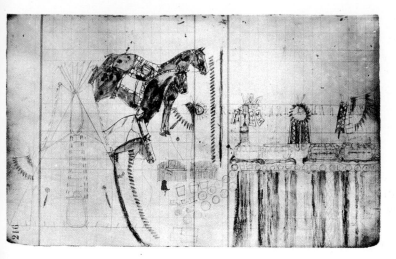

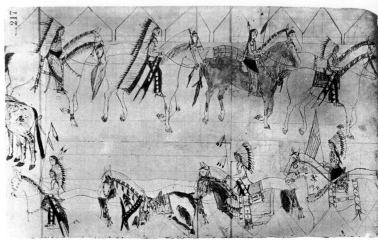

Amos Bad Heart Bull, a Lakota artist who witnessed and illustrated the Fourth celebrations at the turn of the century, indicates that 1898 was the first year that the Oglala of Pine Ridge celebrated.[18] These celebrations lasted as long as six days and encompassed traditional dancing, "Giveaways," feastings, parades, and mock battles of full-blooded Sioux against mixed bloods and the Indian Police. There was also a reading of the Declaration of Independence (fig. 3), speeches, tugs-of-war, potato races, and other "white" contests. The Fourth of July was a blending of old ways and new, and the American flag was its preeminent symbol.

From the beginning the Fourth of July celebrations reflected traditional Lakota life-style and religion. The illustrations by Amos Bad Heart Bull of a Hunka ceremony (which makes a sacred bond between individuals), parades in traditional dress, war dances, Giveaways (or the divestment of wealth), and *heyoka* (or sacred clowns performances), taking place on the Fourth caused Helen Blish to observe, "They are distinctly a part of later reservation life; yet they express a desire for the old-time native manner of living, for they are a temporary return to the older habits of life."[19] The Fourth of July was one of the few times when banned traditional religious practices were tolerated or even sanctioned by the U.S. government, so the symbol of that holiday, the American flag, assumed a special meaning to the Lakota and was incorporated into their traditional dress and artifacts for that day.

Although there is a gap of some fourteen years between the banning of the Sun Dance and the beginning of the Fourth of July celebrations, a relationship between the two should not be discounted. When the Lakota adopted this patriotic holiday, they incorporated within it some of their own traditions. Elements of the traditional Sun Dance rituals appear in the Lakota Fourth of July celebrations, and Sun Dance imagery shares some of the same design motifs and colors with the American flag—similarities that would not have escaped the late nineteenth-century Lakota.

Both events were gatherings of the Lakota bands, and both took place in early summer. The Fourth of July dance, or parade ground, with the camp arranged outside and around the traditional semicircular shade bower, or lodge,[20] appears to be styled after the traditional Sun Dance

circle. The custom of Giveaways, the divestment of material wealth, was an important component of both the Sun Dance and the Fourth of July celebrations. According to Little Wound, Lone Star, and American Horse, Oglala holy men interviewed by James Walker in 1896, a man who pledges the Sun Dance must give away all his possessions (fig. 6), and his people must give feasts and presents.[21] Lakota Fourth of July "chiefs" were also expected to give away all their possessions. In both ceremonies the bower opens toward the east and the center of the dance circle is a pole or tree. The Sun Dance pole is a forked tree—the sacred *Wakan* tree—whose function, colors, and designs share similarities with the American flag and flagpole as used in Lakota Fourth of July celebrations. The base of the Sun Dance pole is peeled white and painted red on four sides, representing the four directions and recalling the red and white stripes of the American flag. Rawhide cutouts of a man painted red and a buffalo painted black hang from the red-painted top branches, and red cloth or calf's skin, which acts as a flag or banner, is placed in the fork of the pole. A cross made from chokecherry branches representing the thunderbird's nest[22] is tied to one of the pole's forked branches. Crosses were also used by the Lakota to depict stars in their representation of the American flag.

Red is a sacred color and very closely associated with the Sun Dance. The hands of the major participants are covered with red pigment, and their bodies and faces are decorated with red stripes. The white buffalo skull, which represents the Buffalo God who is also honored at the Sun Dance, is decorated with red stripes, as is the face of the Sun Dance candidate, illustrating their special relationship, or "hunka." [23]

Additional American flag elements, such as stars and the colors red and blue, appear in an altar to the west of the Sun Dance pole. The holy man digs a star from the earth, sprinkles it with red clay, and erects "...a pipe and a rod of chokecherry stem completely painted blue."[24] Blue is another important color associated with the Sun Dance because it is the color of the sky when the sun is shining. If the people have committed some offense, the sun will hide his face with clouds, which is not a good omen for the Sun Dance. However the Lakota consider a "blue day" a good day for the Sun Dance.[25]

In Lakota iconography the cross, with its four arms, represents the four winds or four directions. The number four, also prevalent in the Sun Dance, is the sacred number for the Lakota.[26] Most of the stars depicted on the Lakota renderings of the American flag are four-armed crosses and not the five-pointed stars typically found on the American flag. This is partially because it is more difficult to work a five-pointed star in beadwork, however it appears that Lakota artists often intentionally used four-pointed stars. The Morning Star (*anpo wicahpi*) with its four long triangular arms is often specifically represented in Lakota renderings of the American flag's blue cantons. Anpo wicahpi is the star prayed to during a vision quest to give the seeker a vision.[27] The use of the Morning Star in depicting the American flag is a clear example of the Lakota incorporating their own religious beliefs and symbols in representing the American flag (plate 72).

The Morning Star was also an important symbol of the "Ghost Dance" religion, a nativistic, revitalization movement that swept through most of the Plains tribes at the end of the nineteenth century.[28] In James Mooney's classic account of the 1890 Ghost Dance, he noted a small

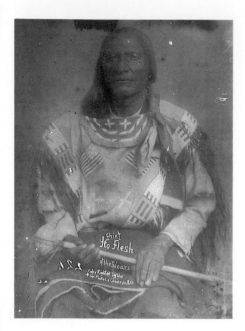

Figure 8. No Flesh, c. 1885
Photographer unknown

tree at one Lakota camp planted in the center of the dance circle "with an American flag or colored streamers floating from the top."[29] This is surprising because one of the tenets of the Ghost Dance ritual was to rid the Plains Indians of the contamination of Euro-American culture, of which the flag was both a symbol and an actual artifact. A possible interpretation is that the Lakota identified the stars in the flag with the Morning Star of the Ghost Dance and the red, white, and blue with their own sacred colors. The Morning Star that appears on some artifacts in this exhibition may refer to or be associated with the Ghost Dance. Big Foot's Miniconjous Lakota band were practicing the Ghost Dance before they were massacred at Wounded Knee. One of the survivors was Lost Bird, a little girl who was found half-frozen in the snow, wrapped in a blanket and wearing a beaded bonnet decorated with American flags.[30] These examples suggest that the American flag could be completely reinterpreted by Native Americans to fit their own needs and beliefs.

The importance of the American flag in Lakota life at the turn of the century can be seen in the illustrations of the Oglala artist-historian Amos Bad Heart Bull. In one such illustration Amos Bad Heart Bull depicts his father, Bad Heart Bull, and Iron Bull on horseback, bedecked in their finery and wearing eagle-plume bonnets in the 1898 Fourth of July celebrations at Pine Ridge Reservation. Each of the men is identified as "chief," an honorary title recognizing him as a leader of the Giveaway ceremony, and each holds a pipe and tobacco bag in one hand and an American flag in the other. Their horses also wear small American flags in their forelocks.[31] In another drawing, Amos Bad Heart Bull records the adoption by the Lakota of the traditional Sun Dance circle into the Fourth of July dance circle (fig. 4). The American flag occupies the place of the traditional sacrificial pole, in the center of the bowered sun-shade circle. In the margin of his drawing, Amos Bad Heart Bull laments that Giveaways, which were traditionally ceremonies honoring the dead or recognizing the achievements of the living, had been exaggerated into a destructive competition among its sponsors. In return for high status accorded to those who sponsor the Fourth of July Giveaways, the sponsors had begun to give away everything, becoming themselves impoverished. Amos Bad Heart Bull wanted to "discreetly regulate" this practice.[32]

Because these lavish Giveaways were incorporated into Fourth of July celebrations, it is not surprising that the American flag, a symbol of the Fourth, should become a decorative element featured on many late nineteenth-century Lakota artifacts. It is quite possible these objects were made to be worn on the Fourth of July or to be given away during the ceremonies. A photograph taken at the Fourth celebrations on Rosebud Reservation in 1897 shows two celebrants wearing flag-decorated costumes. One, probably Louis Roubideaux, a mixed-blood who is acting as a translator, has a quilled flag vest; the other wears a beaded flag blanket strip (fig. 3).[33] The Lakota tradition of creating special gifts of clothing for infants and young children also appeared in these Fourth of July Giveaways, possibly explaining the large number of flag-decorated children's artifacts in these two collections.

The rise of American flag designs on Lakota decorated artifacts also includes pieces made for "Squaw men," a nineteenth-century term for white men married to Lakota women. Many "Squaw men" were former Indian traders who had accepted and been absorbed into Lakota culture,

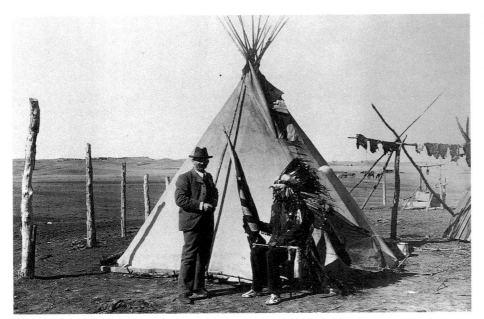

Figure 9. Dr. James R. Walker with Red Cloud, Pine Ridge Reservation, South Dakota, c. 1900
attributed to L. R. Graves

Walker is visiting Red Cloud, who holds an American flag that was probably presented to him during one of his many negotiations with the U. S. government.

receiving all their rights and government annuities through their Lakota wives. They were invaluable to the Lakota because of their knowledge of the customs and language of the white man. A beaded violin case decorated with American flags (plate 64) belonged to George Schmidt, a "Squaw man" who married a Brulé woman and lived on the Rosebud Reservation.

Other American flag designs in Lakota beadwork are simply expressions of patriotism or, at least, of an allegiance to the U.S. By the late nineteenth century some Lakota were closely allied to the U.S. government and its reservation representatives and policies, working for the United States as messengers, interpreters, hunters, and, especially, tribal police. Lakota politics of the late nineteenth century were extremely complex, yet the U.S.Government categorized the Lakota of this period as either "Progressives," who were more closely aligned with federal programs and intervention, or the non-Progressives, or "Traditionals," who were not so aligned and followed traditional tribal law and custom. Because of their more tolerant views especially toward mixed marriages, "Squaw men" were usually allied with the Progressive Lakota.[34] The tribal police, founded by an act of Congress on May 27, 1878,[35] were also made up, on the Sioux Reservation, primarily of Progressive Lakota who were extremely loyal to their Reservation Agent. Their duties and the character of the Lakota recruits were similar enough to those of the traditional Akicita, or soldier/police society, that the tribal police were among the few new institutions to be successfully integrated by the Lakota during the early reservation period.[36]

In traditional Lakota society, Shirt Wearers, so called because they wore distinctive shirts, were "supreme councilors and executives" and the "real power in the government." They were councilors to the acting chiefs and their Akicita society police.[37] A Shirt Wearer's shirt in the Thaw collection (plate 109), is identified through long tradition by its yellow and blue paint and hair locks, but it also features beaded strips depicting American flags rising from complex triangles. The relationship between the traditional Shirt Wearers and the Akicita is quite provocative and illustrates the complexity of Lakota politics of the period. It suggests that the Progressives, who were more closely allied to the U.S. govern-

ment, used American flag designs to show their allegiance. The Progressive Lakota who commissioned these shirts still used traditional symbols of leadership such as the Shirt Wearer's shirt to proclaim their position, however because they ascended to power during the new Reservation system allied with the U.S. government, the shirt stripes are decorated with American flags. A vest decorated with flags (plate 18) that belonged to Thomas American Horse, son of the well-known Progressive leader American Horse, further demonstrates this relationship between the Progressive Lakota and the American flag designs.

The popularity of American flag designs among the Lakota at the turn of the century may be understood as a symbol of protection, commemorating a gift from the U.S. government, war trophies, an attractive popular design, a disguised reference to the Sun Dance, the association of flags with the Fourth of July and "Giveaways," native reinterpretations of the flag, and lastly as a symbol of allegiance to the U.S. government. These possibilities or theories are both numerous and varied and await further research and testing. No one theory is the whole truth, and as is usually the case, the truth lies in the subtle and complex combinations of a number of these factors.

Far removed from the central plains, the Navajo of the Southwest have used American flag design in their weavings since the early 1870s. A photograph taken in 1873 by the renowned photographer of the American West, William Henry Jackson (fig. 11), shows a flag weaving still on the loom. The weaving provides evidence that American flags were among the first asymmetrical designs used by Navajo women in their work.

Ironically, the Navajo had been allowed to return to their lands for only five years before this photograph was taken, after four years of brutal incarceration at Fort Sumner. Because of the horrible conditions, nearly one quarter of the tribe died from disease, exposure, and malnutrition. This experience, in addition to a long history of bloody skirmishes with the U.S. army, surely made the nineteenth-century Navajo acutely aware of the power represented by the American flag. As with the Lakota, the continuous display of the flag at forts, Indian agencies, trading posts, schools and other territorial structures, as well as its conspicuous use by the military in parades and daily flag ceremonies, must have made the Navajo recognize the importance of and the high esteem that Americans had for their national symbol.

The Navajo traded their weavings with outsiders and other tribes. The establishment in the 1870s of government-licensed trading posts on the reservation further enabled the weavers to develop a market-oriented relationship with the whites. By the end of the nineteenth century the Navajos were wearing Anglo-style clothing, and blankets intended for wearing, for which the Navajo had been so famous, were replaced by commercially made blankets obtained at the trading posts. The traders encouraged the Navajos to weave thicker blankets that could be used as floor rugs, a product more easily marketed to Euro-Americans.

The classic designs that were used in wearing blankets were replaced by designs that were created by the traders mindful of the tastes of the American buyers in the east. Others were inspired by motifs found in Oriental carpets. The American flag was a design that would have obvious appeal as a novelty to reservation traders and their customers. The adaptation of First and Second Phase wearing blankets with their formats

of stripes and the palette of red, white, and blue yarns to the relatively simple design of the flag was not difficult, although the flag was rarely rendered literally. The size of the canton or the number of stars and stripes appear to have been determined by the size of the piece that had been planned and an arrangement or configuration that was convenient or pleasing to the maker. As Mark Nohl observed, "Seldom does Old Glory come from the Navajo loom in the traditional...[format]. It may be shortened into a square, elongated into a strip, or have eagles or messages woven into it. It may have a few fat stripes or a number of long skinny ones. It may have stars that look like anchors or flowers, and it may not be red, white, and blue. But it is always recognizable."[38] The six flag weavings that are in the Thaw and Kopp collections (plates 103-108) show the variety and diversity of the individual weavers' concept and execution of the American flag into a woven format.

Another tribal group whose crafts are well represented in both collections are the Plateau Indians of the mid-Columbia area of Washington, Oregon, and Idaho. These include the Yakima, Nez Perce, Warm Springs, Klickitat and Umatilla. The American flag design appears most often in their flat beaded bags and woven cornhusk containers. The earliest objects that incorporate the flag were created in the late nineteenth century, but they seem to have become most popular around World War I, when a tremendously high percentage of eligible male Plateau Indians enlisted in the U.S. army.[39] Howard Bad Hand has pointed out that serving in the army was the only legal way for American Indians to participate in and preserve their warrior tradition. For the people of the Plateau, the Fourth of July and Veterans' Day are major celebrations, with parades, color guards, special ceremonies, and Fourth of July Giveaways similar to those of the Lakota. American flags are conspicuous and abundant at these events, and it is for these occasions that many of the objects created with the American flag motifs were made and worn.

Whatever the sources for the flag imagery, whether the Sun Dance, appropriating a symbol of power, an amulet of protection, tourist-related sales, or sheer American patriotism, the results were the creation of many curious and beautiful works of Native American art. The variety of successful aesthetic solutions for the incorporation of the American flag into the designs for traditional items of clothing and on objects of daily use is a testament to the creative inventiveness of the Native Americans, even during the confinement of the early reservation days.

1. *Sioux* is a French corruption of a name given to the Lakota people by their enemies, the Chippewas. Because in the Chippewa language the name refers to lesser snakes, many contemporary Western "Sioux" prefer to use their own name, *Lakota*.
2. Pohrt 1975: 3, 5. The Sioux kept a pictographic record of time by a simple drawing of the most significant event of that year.
3. Powers: personal communication, 12.18.92.
4. Grinnell 1915: 170.
5. Mooney 1965: 114, 115.
6. Powers: personal communication 12.18.92.
7. Lincoln 1992: 52-56.
8. Pohrt 1975: 6.
9. Pohrt 1975: 9.

10. Dyck 1971: 96, 129; Hamilton & Hamilton 1971: 144, 192, 300..

11. Stilwell flyer from the personal collection of Dennis and Rose Mary Lessard.

12. Pohrt 1975: 9.

13. Utley 1984: 243.

14. Hyde 1956: 75. It is quite likely that the Sun Dance was secretly held in remote parts of the reservation during the years it was banned by the United States government (personal communication William Powers: 12-22-92). This is further substantiated in an article dated September 13, 1928, *Todd County Tribune*, recording a special permit from Washington to the Brulé of Rosebud allowing them to perform the Sun Dance. The last line states "Some [Brulé?] even hint that it [the Sun Dance] has been done in secret since the government prohibition of it began" (Hamilton & Hamilton: 1971: 149). Even if this is the case, it does not invalidate the fact that Fourth of July celebrations took on at least some aspects of the government-banned Sun Dance. The Fourth of July celebrations allowed for the large social gatherings of the old Sun Dance. Clandestine Sun Dances by their very nature would have to be small. One important aspect of the Sun Dance was that an individual's sacrifices in the form of fasting, praying, and finally piercing and ripping the flesh were publicly validated and that the holiness or goodness of the act would benefit the witnesses. Though piercing was not allowed, sacrifices such as the chiefly Giveaways, the complete divestment of personal wealth as recorded by Amos Bad Heart Bull, could be performed in public and witnessed by the people (Blish 1967: 424).

15. Utley 1963: 31–32.

16. Pohrt 1975: 9.

17. Hamilton & Hamilton 1971: 187.

18. Blish 1967: 42.

19. Blish 1967: 43.

20. Blish 1967: 424, 466. The leafed bower can also be seen behind the Fourth of July participants in a John Anderson photograph (Hamilton & Hamilton 1971: 186, pl. 124).

21. Walker 1980: 181.

22. Powers 1977: 97; Walker 1980: 179.

23. Walker 1917: 69, 71, 97, 99.

24. Walker 1980: 180; Walker 1917: 105.

25. Walker 1917: 105; Walker 1980: 180.

26. Powers 1986: 128-144. The other sacred number, seven, is used less consistently in the Lakota flag designs, although there are a number of examples with seven stripes in this exhibition.

27. Powers 1977: 92.

28. The Ghost Dance consisted of a ceremonial complex of songs, dances, special ritual clothing, and paraphernalia. It was believed that its performance would bring about the disappearance of the white man and the return of the buffalo and the traditional lifeways, including dead ancestors and loved ones—hence the name "ghost." It was adopted by the Lakota in a more militant form.

29. Mooney 1965:68.

30. ibid.: 132.

31. Blish 1967: 423.

32. ibid.: 424.

33. Hamilton & Hamilton 1971:192, pl. 133.

34. Hyde 1956: 71, 235.

35. Hyde 1956: 29.

36. Utley 1963: 26, 28.

37. Wissler 1916: 7, 8.

38. Mark Nohl, "Long May It Wave," *New Mexico Magazine* 26-27 (1976); 51ff. Flag rugs are not common, as there was a reluctance by Americans to walk on a flag. Most of those weavings were purchased as wall hangings or as souvenirs and curiosities.

39. This was also true in World War II, the Korean War, and Vietnam.

CATALOGUE

· ·

A note on the materials used
in making Indian artifacts

SINCE THE FIRST VOYAGE of Columbus in 1492, glass beads
of European manufacture have been used for trade with
Native Americans (Hail 1980:51). Most, if not all, of the
glass beads used to decorate the various artifacts in this
catalogue were made in Venice, Italy. Through a complex
network of commerce they were shipped to all parts of
North America, where they were traded for such native
products as furs and hide. Called seed beads, they have
been applied primarily to the hides with sinew, fibrous
strands of dried muscle tissue which are used as threads.
Actual cotton and linen threads obtained through trade
were used by some tribes, especially those of the Plateau
area of eastern Washington, Oregon, and Idaho.

Other decorative objects on artifacts in this
exhibition are made from porcupine quills. These long
tubular plastic-like quills, or spines, were first colored with
natural or, beginning in the 1870s, commercial aniline
dyes. They were then softened and flattened. The quill-
worker, as the earlier beadworker always a woman, applied
them to the hides with a variety of techniques that included
wrapping, plaiting and sewing. The fading on some of the
objects is due to exposure over time of the fugitive dyes to
ultraviolet light.

The hides on which the beadwork and quillwork
have been applied come from buffalo (although virtually
extinct by the late 1880s, earlier hides were reused), cattle,
elk and reindeer. These various skins were primarily pro-
cessed by a technique known as brain tanning. Skins were
first scraped of flesh, gristle, fat and hair. The hides were
then soaked, sometimes even buried, to make hair-removal
easier and tanned with a mixture of brains and other
internal organs. Finally, the hides were softened, a difficult
and tedious process that could take over a week (Hassrick
1964:210–211).

CLOTHING

BY THE LATE NINETEENTH CENTURY much of the clothing made and worn by North American Indians was a synthesis of native and non-native elements. Europeans introduced new fashions and new materials, such as woven cloth and glass beads, into clothing design, and these were combined with various native traditions to create a distinctive North American form. Colorful designs on clothing were the primary artistic endeavor of many Native American women. Patterns were painted with colored pigments and embroidered with dyed porcupine quills or glass beads, and edges were decorated with fringe, calico, tin cones, and various other ornaments. Certain articles of clothing continue long-established traditions in American Indian culture. These include moccasins, armbands, breast plates, blanket strips, and leggings (plates 1–11). American Indians were quick to adopt the new styles of dress that were convenient or appropriate to their life. In addition, from the 1870s the federal government promoted the use of Euro-American clothing by Native Americans. Although in many instances particular designs might be taken from Euro-American fashions, the decoration and materials created a new form that perpetuated native traditions (plates 12–30).

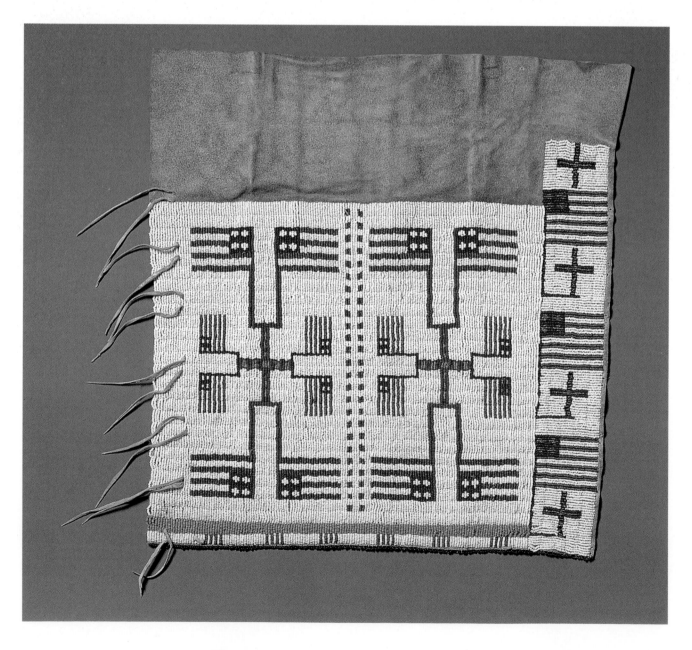

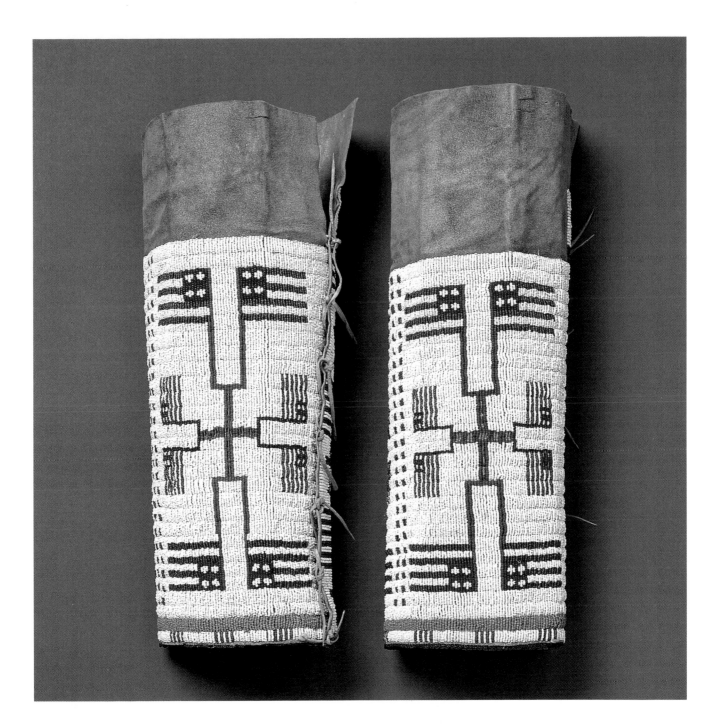

1.

WOMAN'S LEGGINGS
Lakota
Circa 1890
Native tanned cowhide,
glass and metal beads.
h. 16"; w. 15 1/2"

Leggings were worn by both men
and women. The size, shape, and
decorative layout of this pair indicate
that it was made for a woman. The
geometric pattern of the beadwork
is one of the most sophisticated
versions of traditional Lakota design.
The figure at left shows one legging
untied and extended flat.
Thaw Collection

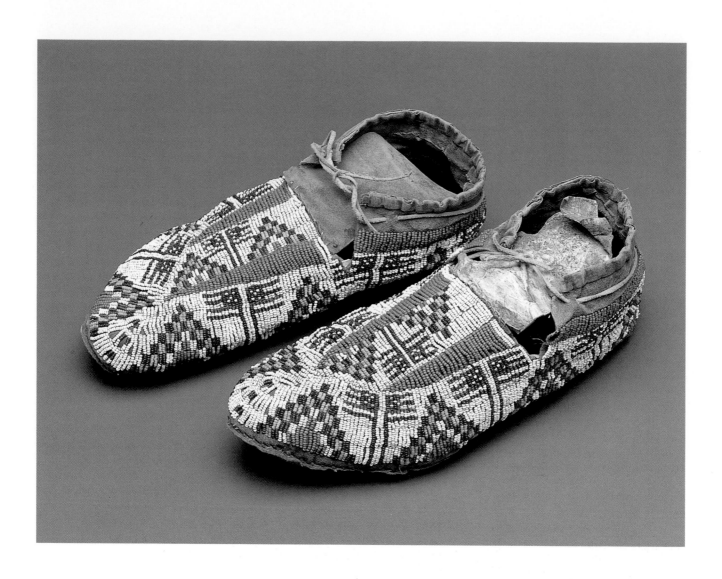

2.

MOCCASINS
Lakota
Circa 1890–1910
Native tanned hide, glass beads,
brown velvet binding; the drawstrings
and one tab are later replacements.
h. 3 1/2"; l. 10 1/2"; w. 3 3/4"

While the design is very similar to
plates 7 and 68, the placement and
scale of the different elements are
masterfully done.
Thaw Collection

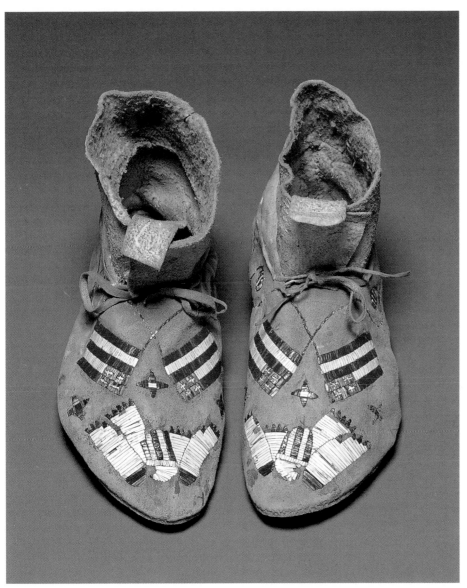

3

MOCCASINS
Lakota
Late 19th to early 20th century
Native tanned hide, porcupine quills.
h. 5 ⅝"; l. 10 ⅝"; w. 4 ⅛"

Extended cuffs, which wrap around
the ankles, indicate that these
moccasins were owned by a Lakota
woman. The soles are reworked
parfleche.
Thaw Collection

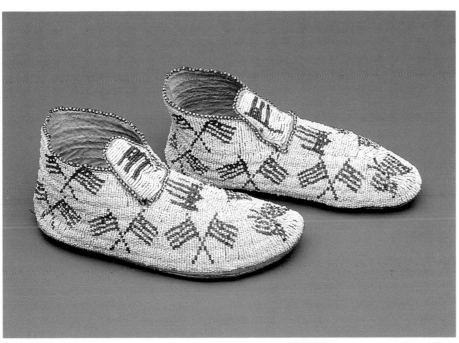

4.

MOCCASINS
Southern Cheyenne, Oklahoma
Early 20th century
Native tanned hide, glass beads.
h. 4"; l. 9 ½"; w. 3 ¼"

The moccasins are stuffed with a
1960s newspaper from Bartlesville,
Oklahoma, and a cardboard liner
cut from an egg crate from Pawnee,
Oklahoma. These facts and the
construction style of the moccasins
suggest a Southern Cheyenne origin.
Thaw Collection

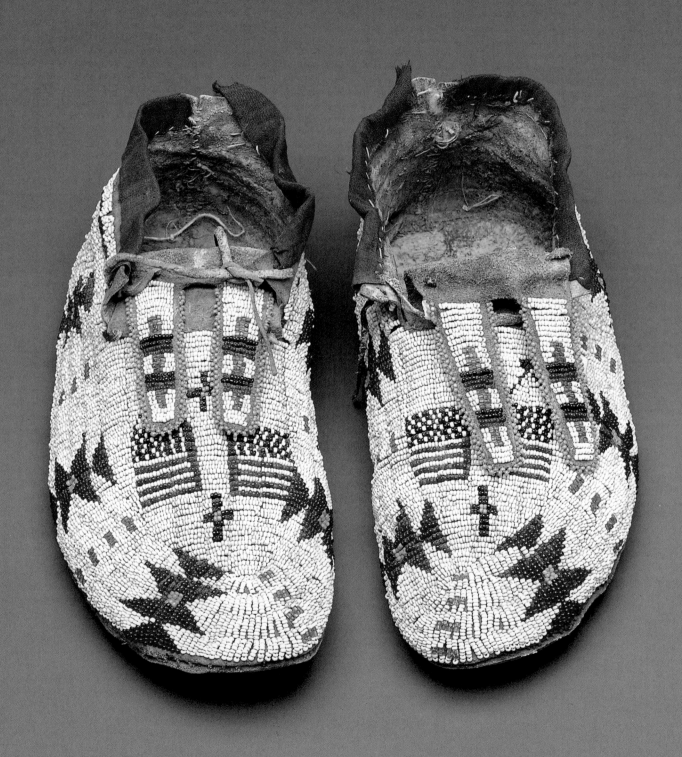

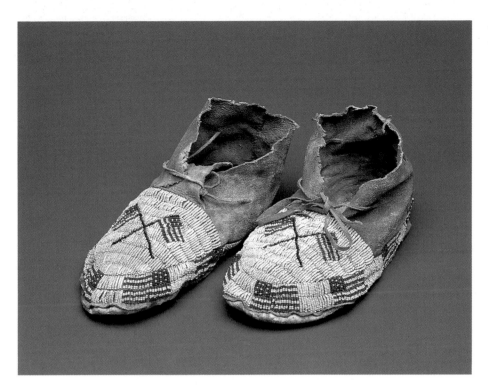

6.
MOCCASINS
Probably Lakota
Late 19th century
Native tanned hide, glass beads, red
wool.
l. 10"; w. 3 ¾"
Kopp Collection

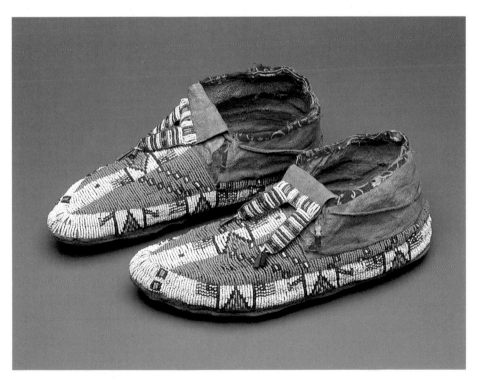

7.
MOCCASINS
Lakota
Late 19th century
Native tanned hide, glass beads, tin
cones, printed calico binding.
h. 33 ¾"; l. 10 ½"; w. 3 ¾"

The multicolored stepped triangles
around the sides of the green
buffalo tracks are popular designs
on Lakota moccasins from the end
of the nineteenth century.
Kopp Collection

< 5.
MOCCASINS
Probably Lakota
Late 19th century
Native tanned hide, glass beads.
l. 10"; w. 3 ¾"
Kopp Collection

8.

BREASTPLATE
Iroquois or Northeastern Indians
Late 19th to early 20th century
Blue silk velvet foundation, glass
beads, cotton back.
h. 13½"; w. 8"

The use of clear and colored beads in
designs incorporating flowers, leaves,
and birds illustrates the elaborate style
that evolved among the Iroquois and
Algonquin tribes of the northeast in
the late nineteenth century. This type
of embroidery is typically seen on
pillows, pincushions, and hanging
boxes made for tourists, but the un-
usual form and heavy wear on this
breastplate suggest that it was made
for American Indian use.
Kopp Collection

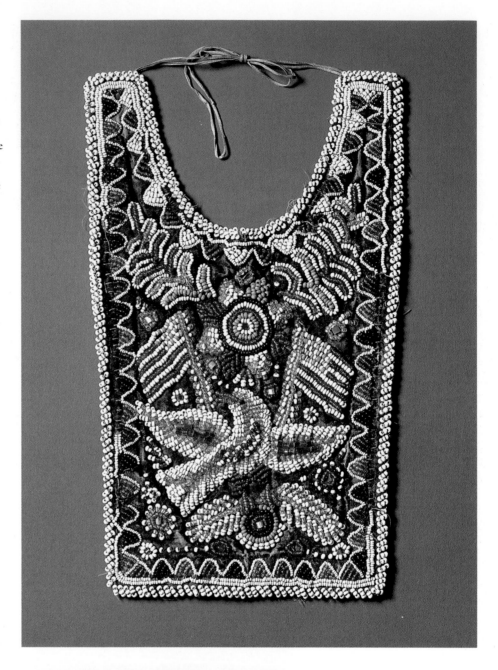

9.

ARMBAND
Lakota
Circa 1920–1940
Glass beads, cotton lining.
h. 2⅜"; d. 3¾"

Silver armbands engraved with the
arms of the United States were
given to chiefs and important
warriors as early as the 1790s.
Although this native-made example
was made many decades later, it is
similar in design with the addition
of two flags.
Thaw Collection

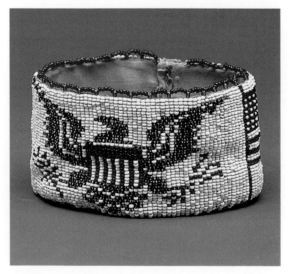

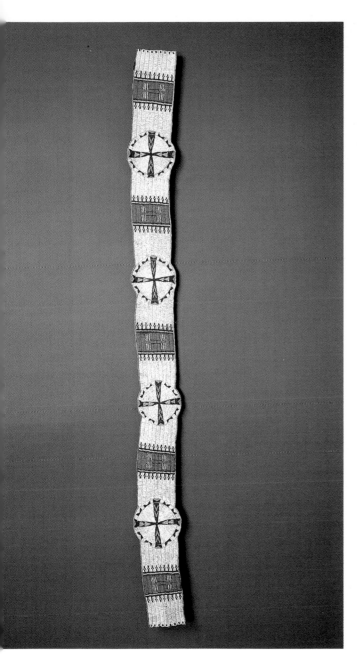

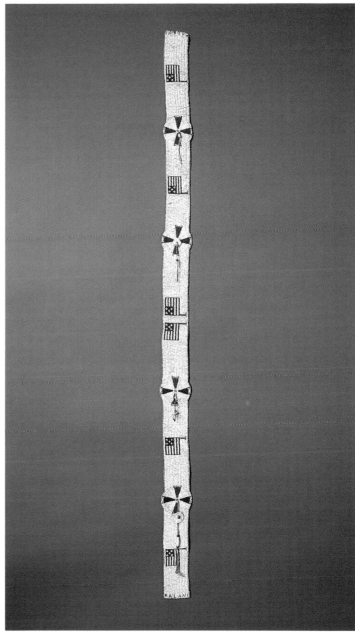

10.
BLANKET STRIP
Lakota
Late 19th century
Native tanned hide, glass beads.
l. 66"; w. 5½"

The designs, balance, and color
choices of the beadwork and the
unusual width and overall dimensions
suggest a date early in the Reservation
Period (Hail 1980:138).
Thaw Collection

11.
BLANKET STRIP
Lakota
Late 19th to early 20th century
Native tanned hide, glass and metal
beads, red-dyed thongs, brass beads,
and shell pieces.
l. 63½"; w. 3½"

Blanket strips originally were made
to cover the seams where two halves
of a buffalo hide were joined after
tanning. By the end of the nine-
teenth century hide blankets were
no longer in use, but the beaded
strips continued to be applied to
commercial woolen blankets and
served as symbols of wealth and
status. The word "Palani," beaded on
either end, is the Lakota name for
the Arikera tribe (Personal communi-
cation, Dr. William Powers, Jan.
1993). It may refer to an Oglala
family of the name Kills Ree, Ree
being an abbreviation of Arikera,
who lives at the Pine Ridge
Reservation, South Dakota.
Thaw Collection

12.

VEST
Lakota
Late 19th to early 20th century
Native tanned hide, glass beads,
leather fringe, blue calico binding,
red calico lining.
l. 20 ¾"; w. 17 ½"

Vests were part of European male
attire from the late sixteenth century.
Starting in the 1890s Lakota women
created a distinctive style which,
although based on the contemporary
Euro-American form, was covered
entirely with beadwork that often
incorporated pictorial scenes. The
radical stylization of the American flag
is compatible with the austere layout
of the horse and three hoofprints.
Kopp Collection

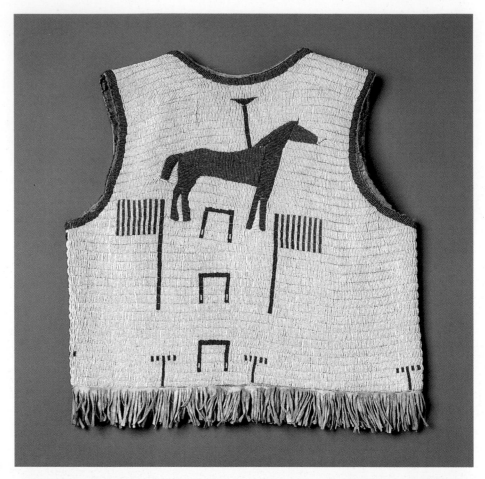

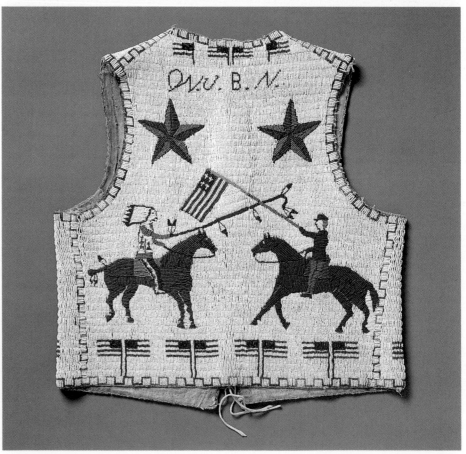

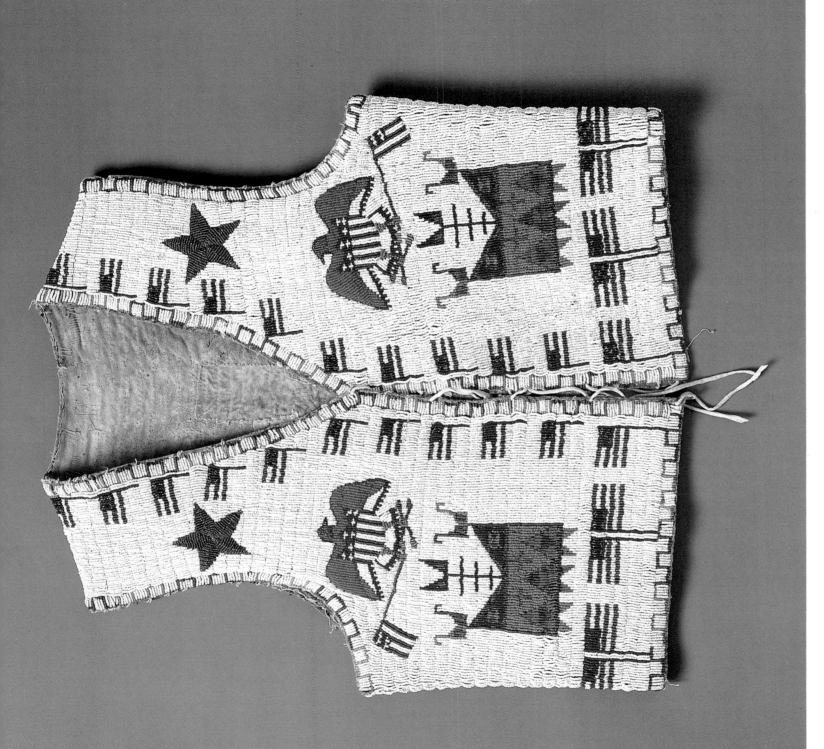

13. ABOVE AND OPPOSITE
VEST
Lakota
Late 19th to early 20th century
Native tanned hide, glass beads,
cotton lining.
l. 21"; w. 19¹/₄"

The letters "W.U.B.N." across the
shoulders on the back are the initials
of the original owner.
Thaw Collection

14.

Vest
Lakota, possibly Brulé Sioux from
Rosebud Reservation, South Dakota
Late 19th to early 20th century
Native tanned hide, glass beads, silk
ribbons.
h. 20"; w. 16½"

Although the initials on this elaborate
vest seem to be "P.C. Voice," the "C"
may be a "G" and stand for Good
Voice, a prominent Brulé Sioux family
of the Rosebud Reservation.
Kopp Collection

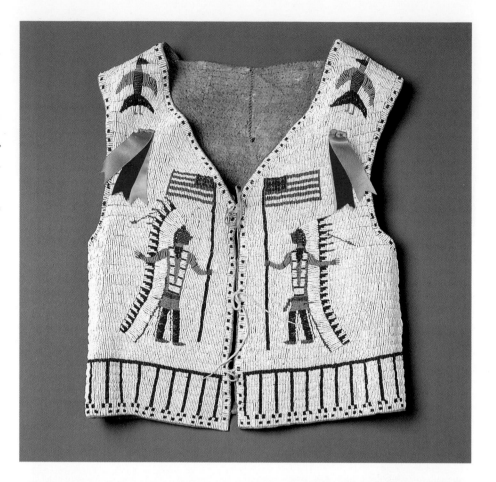

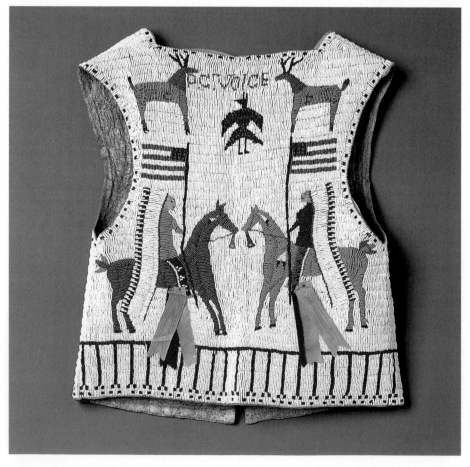

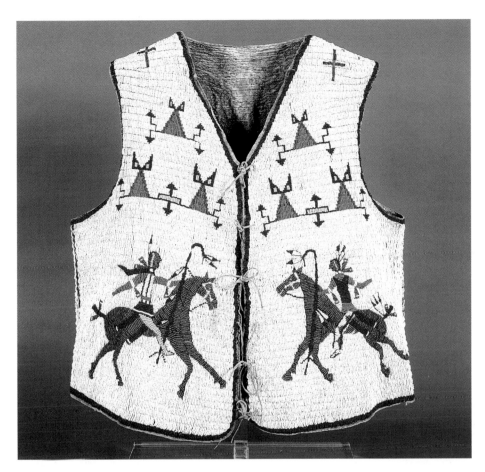

15.
Vest
Lakota
Circa 1890
Native tanned hide, glass beads.
h. 19"; w. 18"

The beaded images refer to warrior
traditions among the Lakota. The
horses' tails are tied for war and a
trophy scalp hangs from a bridle. One
of the figures on the reverse is a lance
bearer, an important and honored
personage in Lakota warrior societies.
The original owner may himself have
been a lance carrier.
Kopp Collection

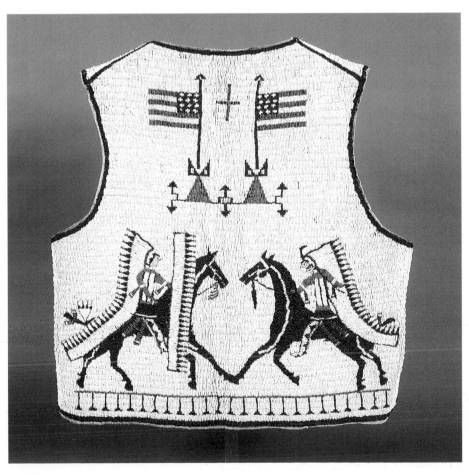

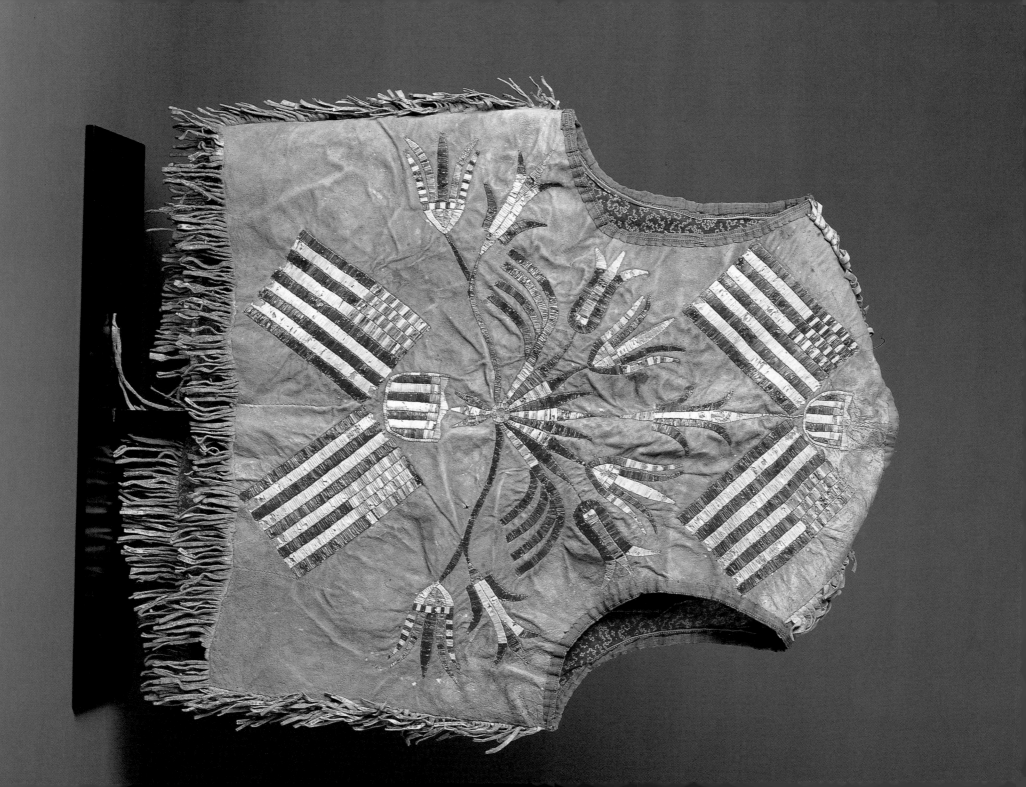

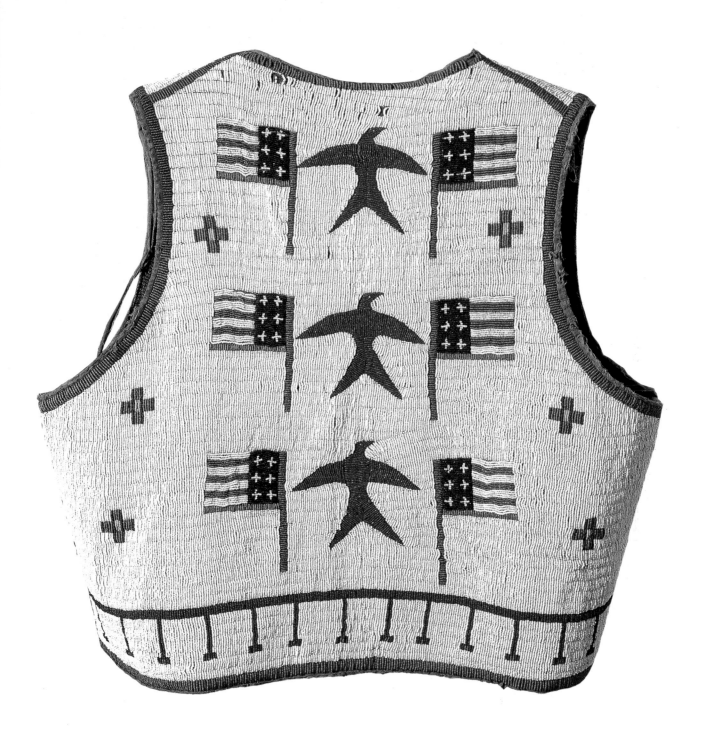

< *16.*
Vᴇꜱᴛ
Lakota
Circa 1890
Native tanned hide, dyed porcupine
quills, printed cotton lining.
h. 22"; w. 19 1/2"

The design on the back of this vest,
with American flags, shields, and a
splay of flowers is typical of Lakota
floral quillwork.
Kopp Collection

17.
Vᴇꜱᴛ
Lakota
Circa 1890
Native tanned hide, glass beads,
printed calico lining.
l. 22 1/2"; w. 23 1/2"

The fork-tailed birds represent
swallows, or possibly thunderbirds,
a motif that may refer to the Ghost
Dance religion.
Kopp Collection

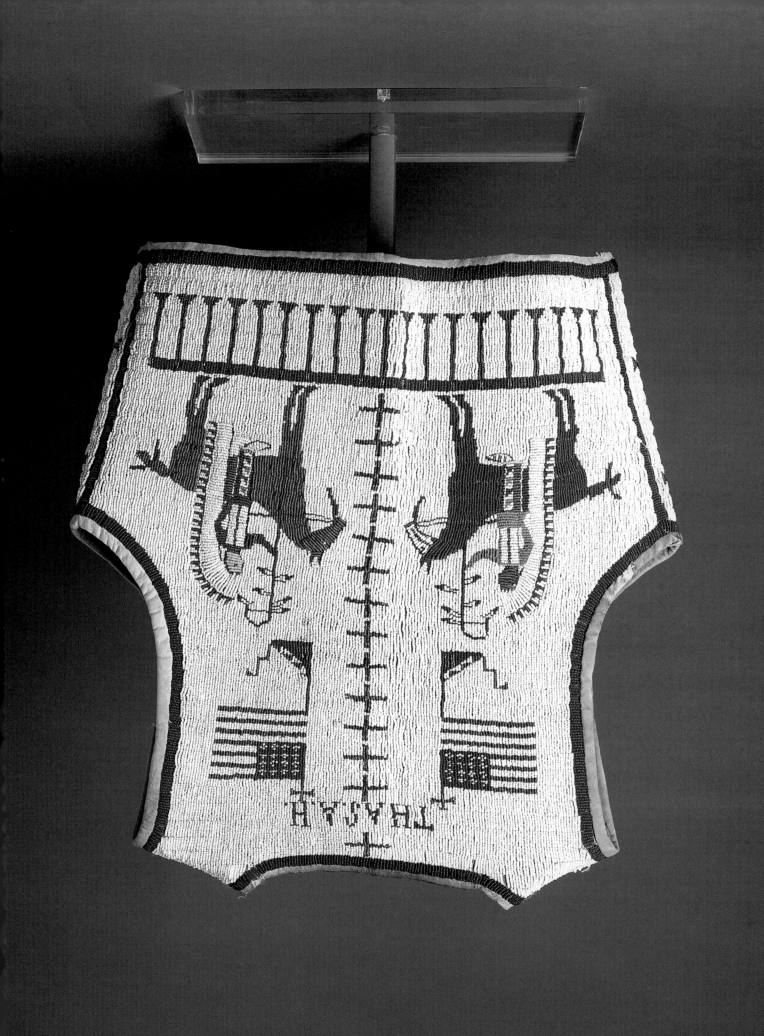

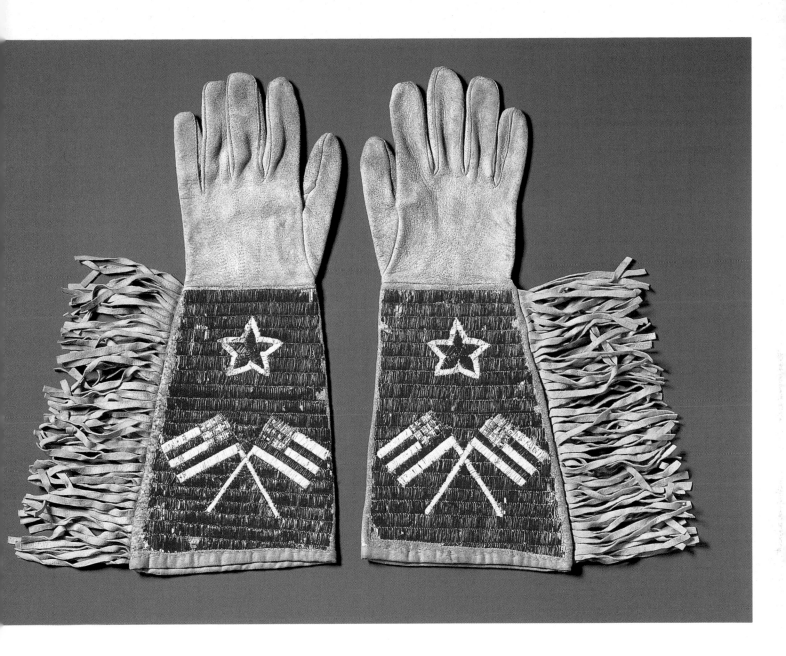

< *18.*

VEST
Lakota, Oglala, Pine Ridge Reservation,
South Dakota
Late 19th to early 20th century
Native tanned hide, glass beads, native
tanned leather binding and lining.
l. 18"; w. 20"

The initials "THAS.A.H." worked in
beads across the shoulders may be those
of the original owner, Thomas American
Horse, a member of the Oglala band of
the Lakota who lived on Pine Ridge
Reservation at the turn of the century.
Kopp Collection

19.

GAUNTLETS
Lakota
Late 19th to early 20th century
Native tanned hide, porcupine quills.
h. 17"; w. 9" with fringe
Kopp Collection

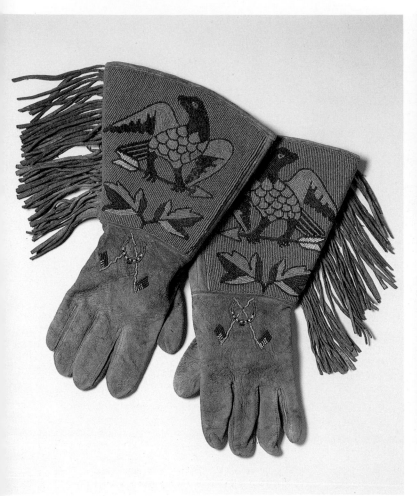

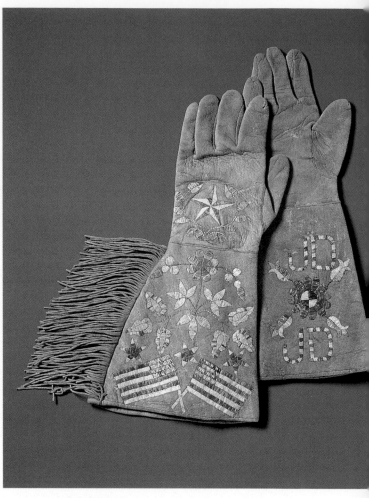

20.
GAUNTLETS
Plateau Indians
Early 20th century
Native tanned hide, glass
beads, cotton plaid
lining.
l. 15"; w. 8½"

Because of the small size
of the flags, the maker
omitted the white stripes
and used only solid red.
Thaw Collection

21.
GAUNTLETS
Lakota
Circa 1890
Native tanned leather, dyed
porcupine quills, cotton
flannel lining.
l. 17¾"; w. 9⅛"

The richly designed quillwork
incorporates the original
owner's initials, "JD," on the
underside.
Thaw Collection

22. >
WRIST BAND
Great Lakes or Lakota
Early 20th century
Thread and glass beads, commercial metal
buckle.
h. 2⅛"; d. 3¾"

This band with the American eagle and
shield is loom-woven, a technique more
common to Native Americans in the Great
Lakes region but adopted by various Plains
tribes in the twentieth century.
Kopp Collection

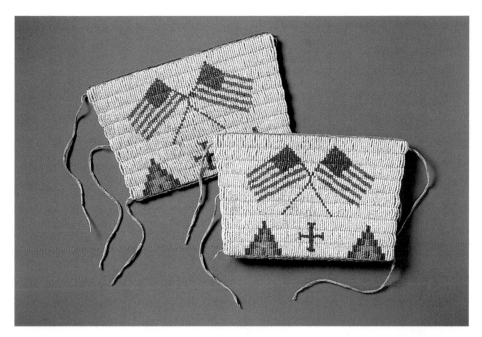

23.
CUFFS
Lakota
Late 19th to early 20th century
Native tanned hide, glass and metal beads.
h. 5"; w. 8"

Decorative cuffs are a standard accessory for dancers' costumes. They are an abbreviated form of the soldier's gauntlets and were probably adopted from cowboy gear.
Kopp Collection

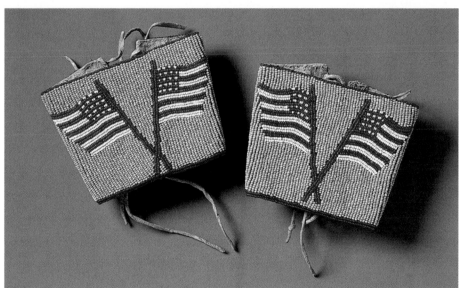

24.
CUFFS
Lakota or Nakota
Late 19th century to early 20th century
Native tanned hide, glass beads.
h. 3"; w. 4"

Cuffs of this design were made for dancers. The pink background and appliqué stitch suggest a Yanktonai origin because these people developed a preference for pastel colors and appliqué beadwork.
Kopp Collection

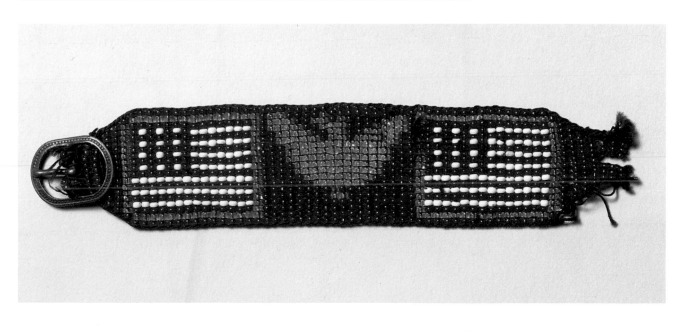

25.

WOMAN'S SUNBONNET
Lakota
Late 19th to early 20th century
Dark brown calico, native tanned
hide, glass beads, rose silk waffle, silk
ribbons.
h. 15"; w. 12"; d. 6"

The maker created the form of a
traditional Euro-American sunbonnet,
but affirmed her native culture and
sewing ability by incorporating a
beaded strip from a woman's legging.
Kopp Collection

26.

BELT
Cheyenne
Early 20th century
Glass beads, commercial leather,
commercial silver-plated buckle, brass
grommets.
l. 45"; h. 1¹/₄"

The beaded portion of this belt was
made on a simple loom and finished
off with a commercial leather tip and
silver-plated buckle. Loom beadwork
is traditional to the Great Lakes
region, but by the early twentieth
century the technique was being
used by a number of other people,
including the Cheyenne and Lakota,
thus making exact identification
difficult. Although the owner's initials
"T. H." are unidentified, an early
collector's label identifies the maker
as Cheyenne.
Kopp Collection

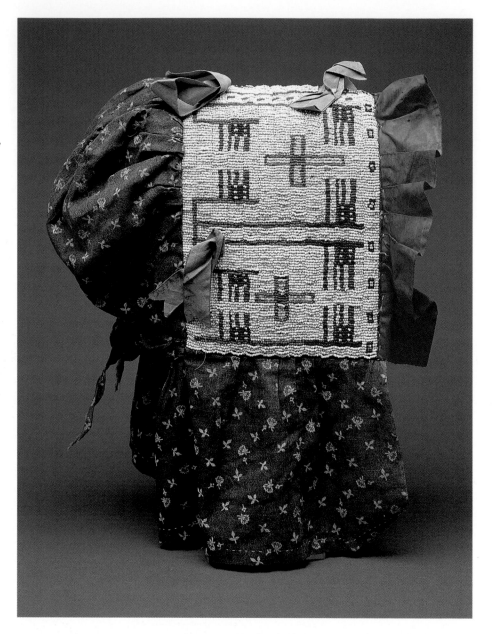

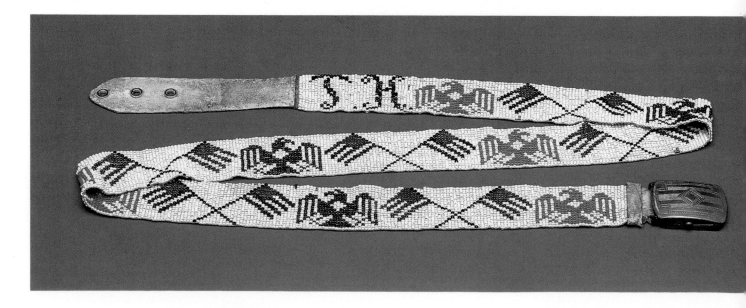

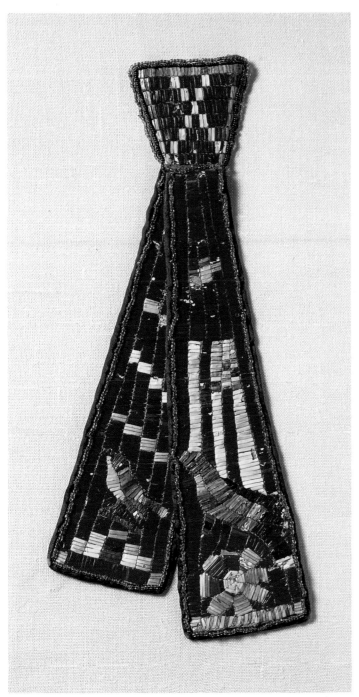

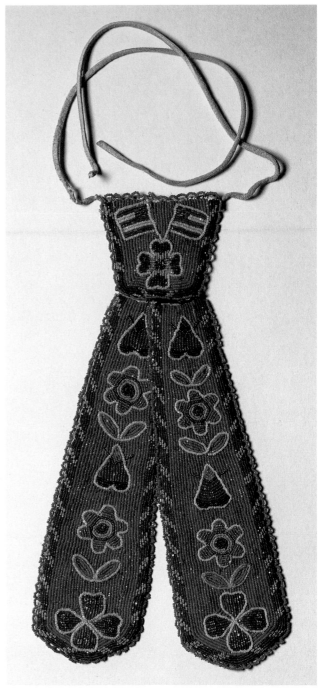

27.
NECKTIE
Lakota
Early 20th century
Hide foundation, porcupine quills,
aniline dyes, metal beads, cloth
edging.
l. 11$^{1}/_{2}$"; w. 5$^{3}/_{4}$"

Neckties of this form were probably
made for native use.
Kopp Collection

28.
NECKTIE
Assiniboine, Northern Montana
Early 20th century
Native tanned leather, glass and metal beads,
patterned silk backing.
l. 11$^{1}/_{4}$"; w. 6$^{1}/_{2}$"

The necktie form is borrowed directly from Euro-
American culture and fashion. This beaded example
ties around the collar with
a leather thong.

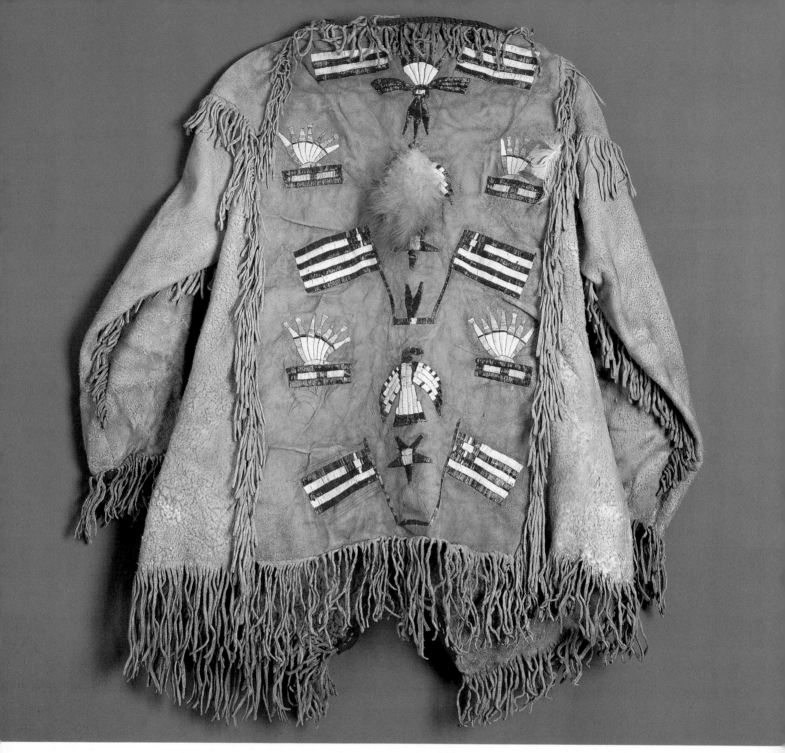

29.
SCOUT JACKET
Lakota
Late 19th to early 20th century
Native tanned hide, stained with yellow
ochre pigments, dyed porcupine quills,
fringe, eagle feathers, cloth.
l. 28"; w. 26"

In addition to six American flags, this
jacket is decorated with a feather splay, or
fan, with ribbon drops between the
shoulders; two thunderbirds, one of which
has eagle down, or a "breath" feather; and
four rectangles with feather splays, the
meaning of which is unknown.
Kopp Collection

30. >
SCOUT JACKET
Lakota
Late 19th to early 20th century
Native tanned hide, commercial cloth
lining, glass and metal beads, weasel-fur
collar, native yellow pigment.
h. with fringe 32 ³/₄"; w. at shoulders 20"

Scout jackets were inspired by Euro-
American style coats and were often worn
by people other than American Indians on
the reservation or in Wild West shows.
One of Buffalo Bill Cody's signature
outfits included an elaborately decorated
scout jacket.
Thaw Collection

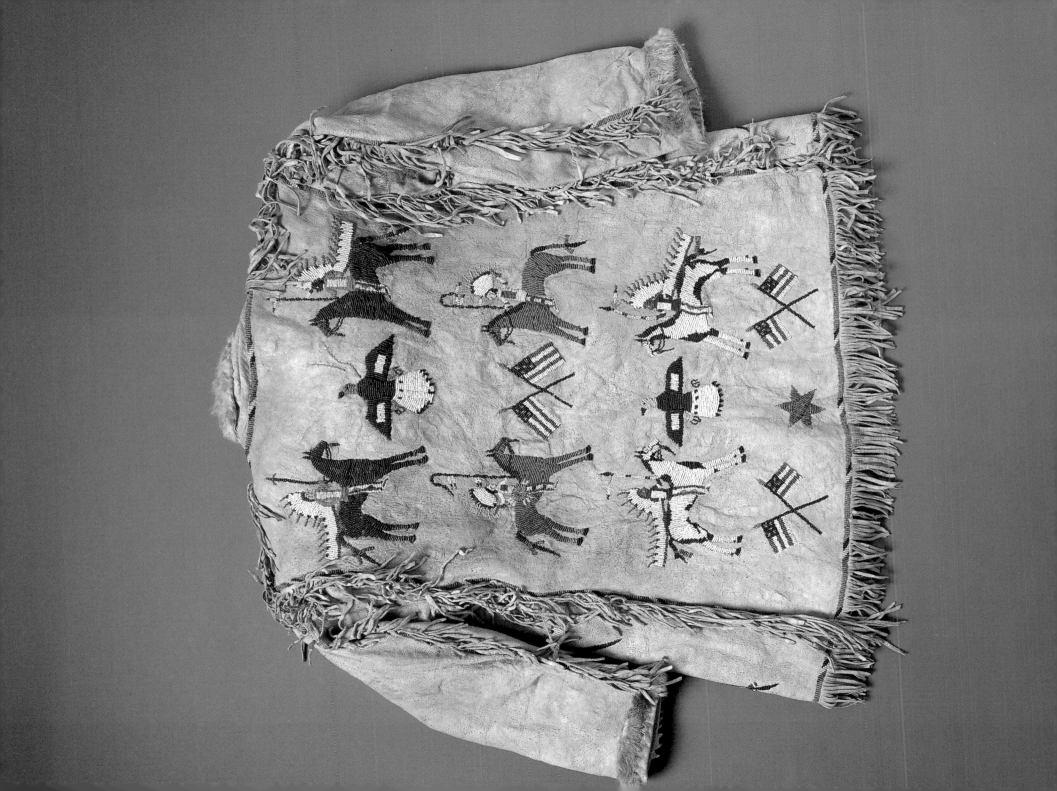

CONTAINERS

ANY PLAINS INDIANS were nomadic or semi-nomadic, so pouches, bags, and other containers were an important part of their traditional culture. With little or no furniture to decorate, American Indians applied their artistic efforts to the sacks and containers, from large to small, that were used to carry their possessions from place to place, to hold personal items, tools or weapons, and to safeguard sacred objects. Some of these forms are traditional, dating to pre-contact times (plates 32–43, 45–50, 52–57). Others were factory-made and supplied from mail-order companies such as Sears Roebuck (plates 59–64).

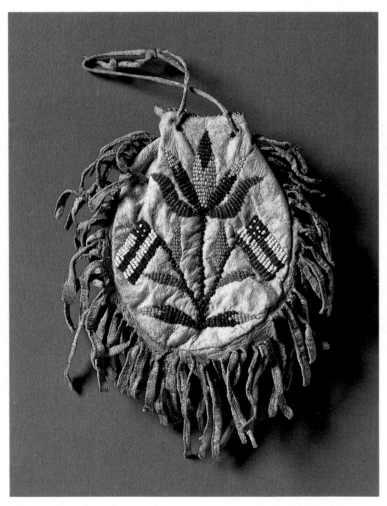

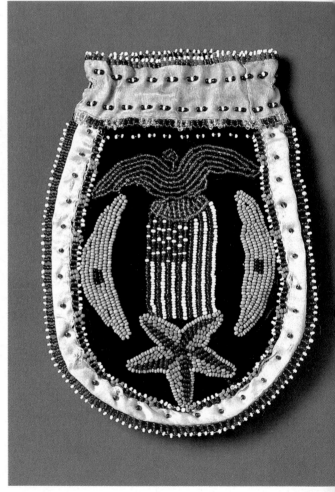

32.
BAG
Lakota
Late 19th to early 20th century
Native tanned hide, hide fringe and drawstring, round and faceted glass beads.
h. 6"; w. 5"

The floral design, incorporating an elaborate central blossom and side branches with American flags, is reminiscent of European folk art traditions.
Kopp Collection

33.
POUCH
Prairie Indians
Circa 1850–1900
Commercial wool cloth, silk ribbon, glass beads, cotton check lining, drawstring missing.
l. 7"; w. 4 ³/₄"

Small pouches of this type were often made for sale, but were also used by American Indians to hold small valuable items.
Thaw Collection

31. >
POUCH
Lakota
Early 20th century
Native tanned hide, glass and metal beads.
h. 11"; w. 6"

The design of the seal of the United States is given a sparkling quality by the use of faceted beads.
Kopp Collection

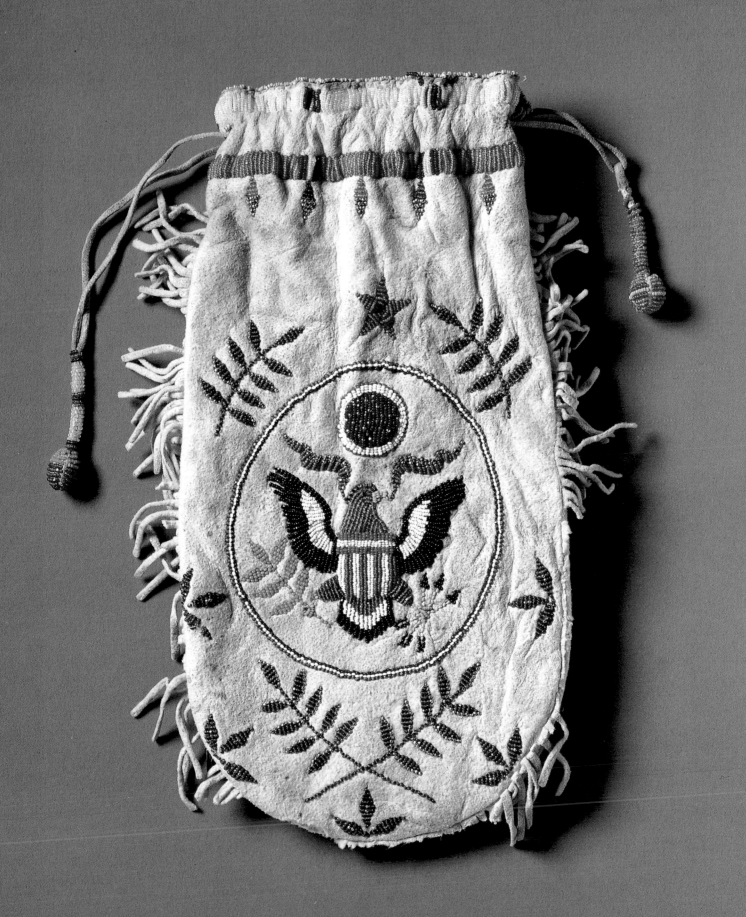

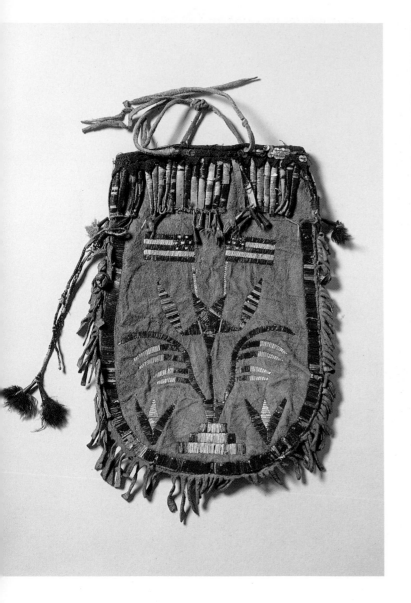

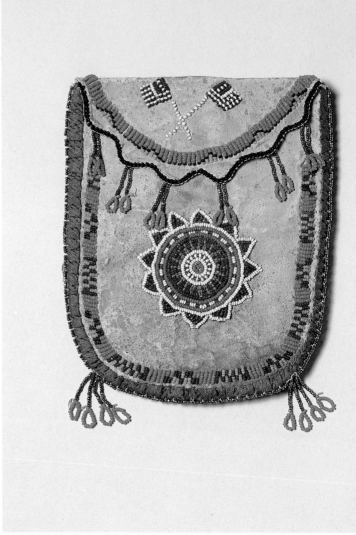

34.
POUCH
Lakota
Late 19th to early 20th century
Native tanned hide, dyed porcupine
quills, feathers, brass hawk bells, tin
cones, paillettes, cotton cloth.
l. 13"; w. 8¹/₂"

The variety of materials used to
decorate this relatively simple artifact
clearly illustrates the Lakota love of
decoration. The central design is a
star-blossomed flower growing from a
stepped pyramid.
Kopp Collection

35.
Pouch
KIOWA, OKLAHOMA
Late 19th to early 20th century
Native tanned hide, native pigment, glass and
metal beads, silk binding.
l. 6"; w. 4¹/₂"

The intense yellow has been achieved by
rubbing the deer or antelope hide in iron oxide
or ochre. The central rondel, with its blue,
green, and white colors and red outer ring, may
refer to the peyote cactus and its hallucinogenic
properties. Members of the Native American
Church, a religion popular among the Kiowa,
eat the cactus as a religious sacrament. Church
members tend to be highly patriotic, many
having served in the U.S. Armed Forces.
Thaw Collection

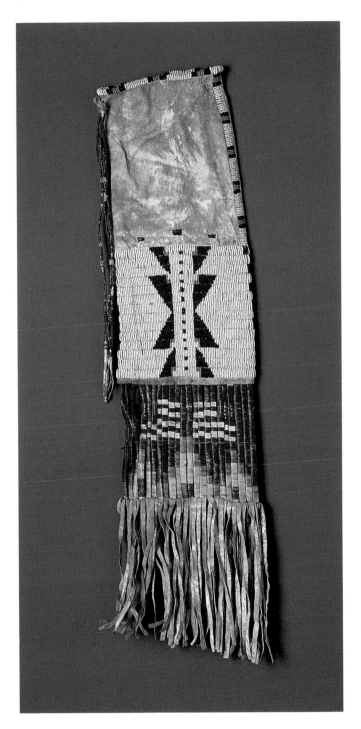
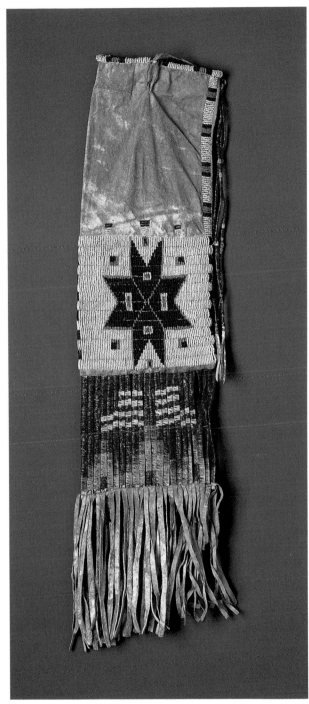

36.

TOBACCO BAG
Lakota
Late 19th to early 20th century
Native tanned hide, glass beads, dyed
porcupine quills.
l. 29^1/$_2$"; w. 6^3/$_4$"

Tobacco bags are long, highly
decorated, rectangular bags made
primarily to hold the sacred plant,
tobacco. Although smoked for
pleasure, tobacco was used as a prayer
and offering to the spirits in its smoke

form. The design of tobacco bags is
entirely traditional, and although such
bags were made for sale, examples with
the American flag were given away at
the special Fourth of July ceremonies.
The use of only two shades of blue
beads on a white field is rare but
provides a strong contrast to the fiery
red, purple, and orange of the
quillwork. By staggering the red and
white stripes of the flag, the
craftswoman created a sense of motion.
Thaw Collection

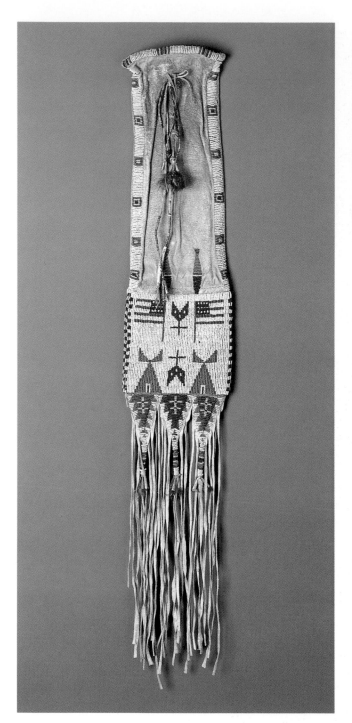

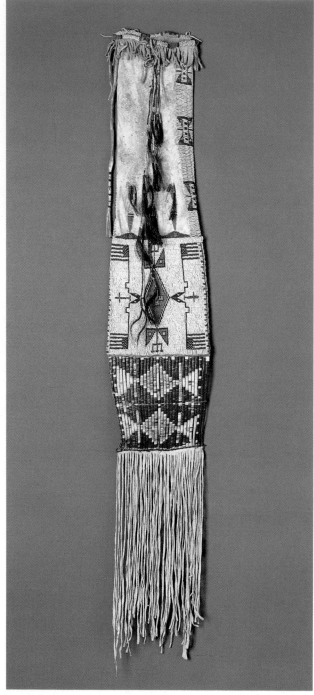

37.

TOBACCO BAG
Lakota
Late 19th century
Native tanned hide, native pigment,
glass beads, tin cones with dyed
feathers, dyed porcupine quills.
l. 33"; w. 5¹/₂"

The beaded triangular tabs at the
bottom of the bag indicate that the
owner may have held a position of
leadership.
Thaw Collection

38.

TOBACCO BAG
Lakota
Late 19th to early 20th century
Native tanned leather, glass beads, porcupine
quills, hair, tin cones.
l. 45 ¹/₂"; w. 7 ¹/₂"

In the drawings by Amos Bad Heart Bull, leaders
of the Fourth of July Giveaway parades each hold
a pipe and tobacco bags. A tobacco bag
decorated with flags would certainly have been
appropriate on such an occasion.
Kopp Collection

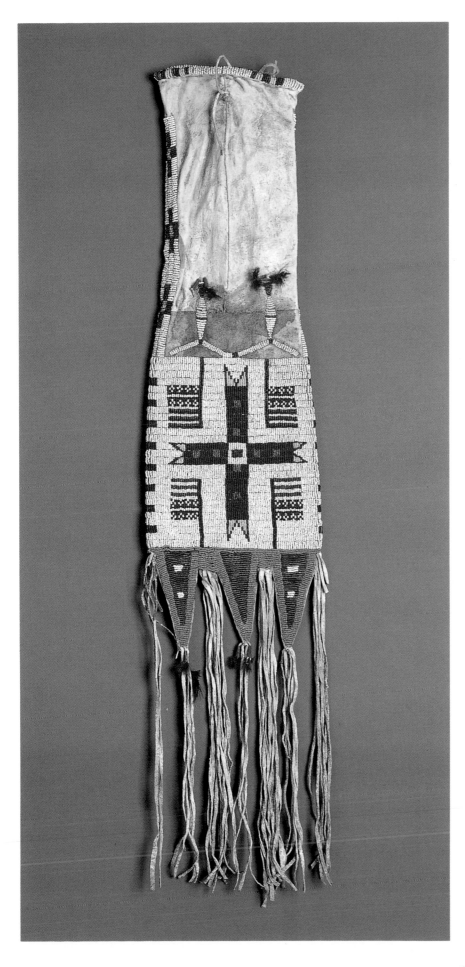

39.

TOBACCO BAG
Lakota or Assiniboine
Late nineteenth century
Native tanned hide, glass beads, tin
cones, dyed feathers.
h. 35"; w. 7¹/₄"

The interpretation of the flags in each
quadrant is most unusual.
Kopp Collection

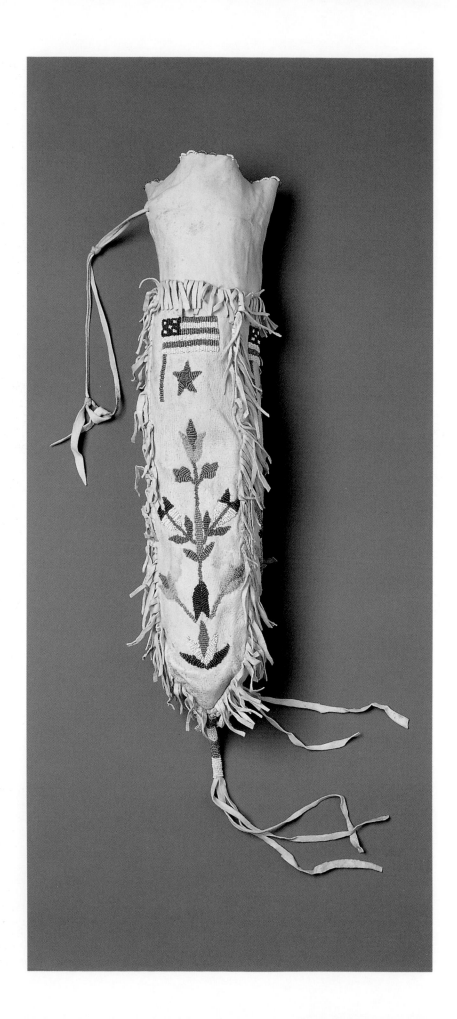

40.
CYLINDRICAL POUCH
Metis Sioux or Lakota
Late 19th to early 20th century
Native tanned hide, glass beads.
h. 31" (with fringe); w. 4"; strap 10"

Pouches of this shape derive from earlier
containers made of buffalo scrotum. These
bags were popular with French fur traders
(Hail 1980: 193) and were brought into
the Red River Metis culture through
intermarriage (Ibid: 195, fig. 249). The
form passed to their southern neighbors,
the Lakota and Dakota.
Kopp Collection

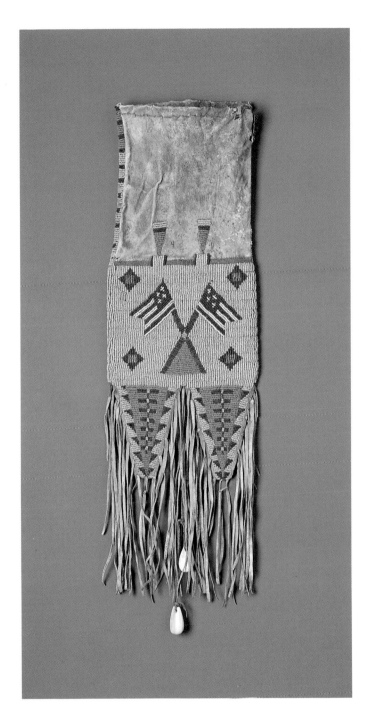

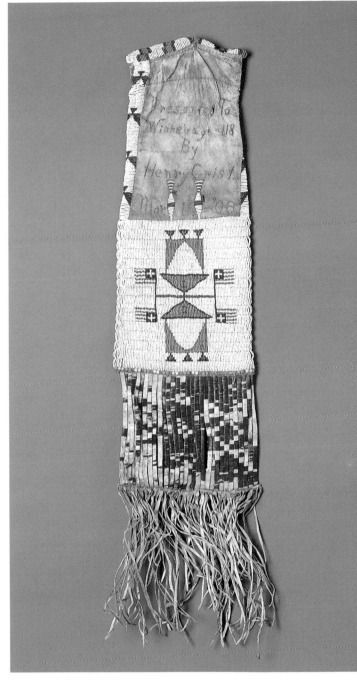

41.

TOBACCO BAG
Lakota or Nakota
Late 19th to early 20th century
Native tanned leather, glass beads,
bones carved in the shape of elk teeth,
upper portion of bag is incomplete.
l. 22¹/₄"; w. 6⁵/₈"

This type of tobacco bag is called a
tabbed bag because of the triangular
appendages at the bottom. The
stylistic origin lies in eastern and
northern regions of the Great Lakes
and dates back to at least the

eighteenth century (Duncan
1989: 91). The overall shape
probably evolved from animal-skin
pouches, with the hind quarters
and occasional tails corresponding
to the triangular tabs. These bags,
like their "whole hide" predeces-
sors, seem to be associated with
medicine (Ibid. 1989: 92). The
light blue background and the
crisper, flatter beadwork style of
this piece are more typical of the
Northern Plains.
Kopp Collection

42.

TOBACCO BAG
Lakota
Late 19th to early 20th century
Native tanned hide, native rawhide, dyed
porcupine quills, glass beads, metal beads.
l. 33"; w. 7¹/₂"

This bag, inscribed "Presented To/
Winnebago-118/By/Henry Crist. / Mar
11, '08" was given to a fraternal
organization, probably the Improved
Order of Red Men, after several years of
American Indian use.
Kopp Collection

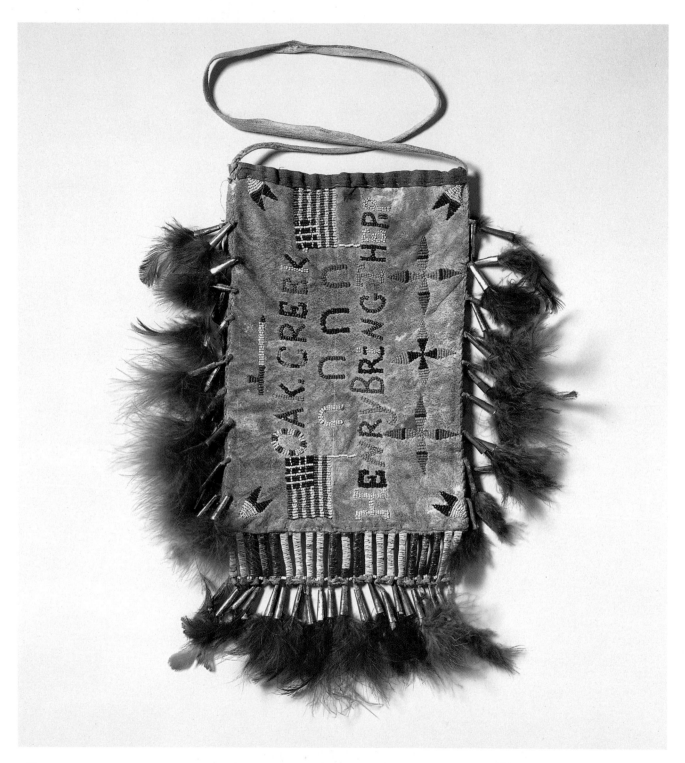

43.

MIRROR BAG
Lakota, Brulé Sioux, Oak Creek,
Rosebud Reservation, South Dakota
Late 19th to early 20th century
Native tanned hide, dyed quillwork,
glass beads, tin cones, dyed feathers,
commercial cloth binding.
l. 13"; w. 9¹/₂"

This colorful bag with carrying strap
was probably a dance piece. The top
line of the design reads "Oak
Creek" for the Oak Creek Commu-
nity of the Rosebud Reservation.
"Henry Bring The Pip" refers to the
original owner, who was named
Henry Bring The Pipe.
Thaw Collection

44.

DISPATCH CASE
Arapaho, Wyoming
Late 19th to early 20th century
Commercial leather, glass beads.
l. 20"; w. 8¹/₂"

This style of pouch is named after the stiff
leather cases used by U.S. soldiers to
carry letters and dispatches. American
Indians adopted the form to carry their
mirrors and toilet articles.
Kopp Collection

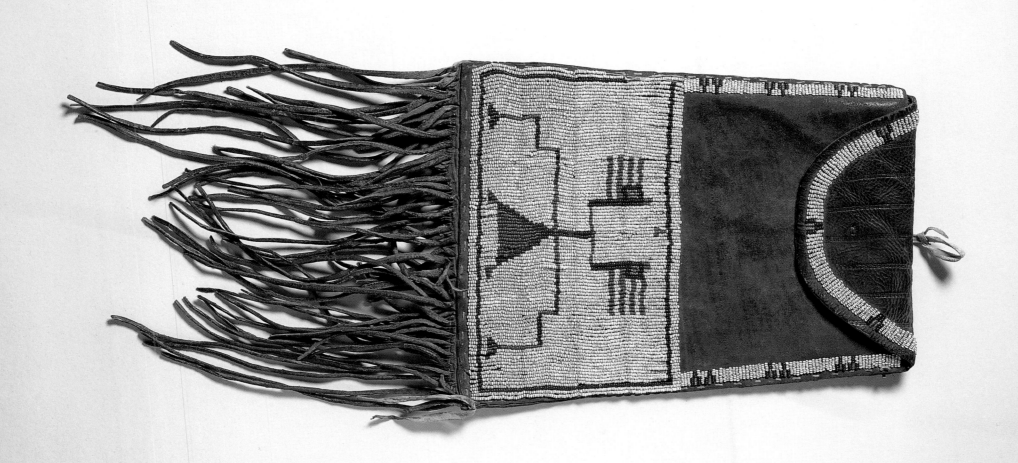

THE PLATEAU INDIANS who were hunters and gatherers needed an assortment of strong, flexible containers to store and transport their roots, berries, and fish. During the reservation period in the late nineteenth century, bags and baskets were no longer necessary for gathering and storage, but the more sedentary life-style allowed more time for weaving. The weavers began to create highly decorative bags as show pieces and greatly expanded their repertoire to include both geometric and figural designs. The bags have a different pattern on each side, although both surfaces are woven contiguously and simultaneously. They were highly prized and were made for the weaver's own use or as gifts. On rare occasions they were offered for sale or used for trade with other tribes. The Columbia River plateau includes the territory that lies between the Rocky Mountains and the Cascade Range and extends from the Columbia River in the south into British Columbia in the north. The native peoples of this area form several linguistic groups, the largest of which are the Sahaptin and Salish. Among these, the Nez Perce, Umatilla, Yakima, Klickitat, Walla Walla, and Tenino are the acknowledged masters of cornhusk weaving.

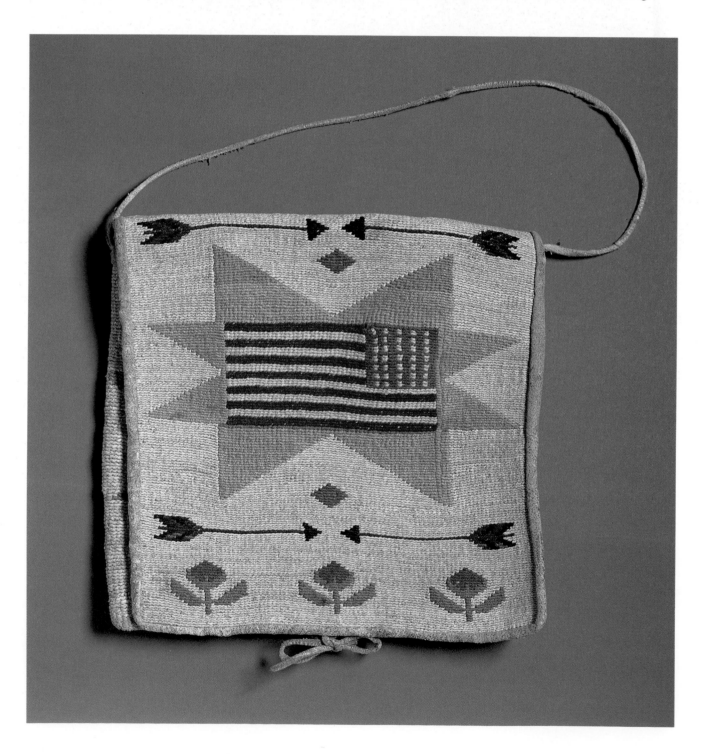

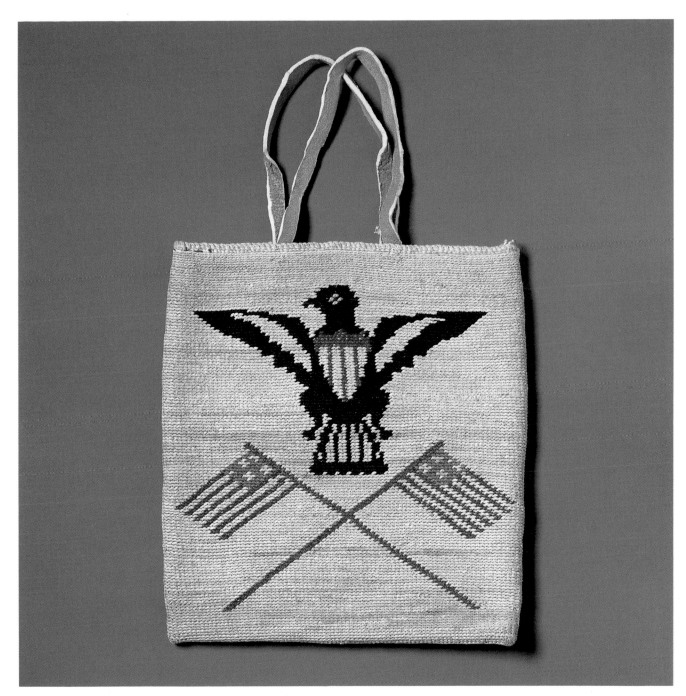

_{<} *45.*

CORNHUSK BAG
Plateau Indians
Late 19th to early 20th century
Cornhusk, wool yarn, commercial
cloth, native hemp.
l. 9"; w. 9 1/8"

By tradition cornhusk twining is used
to construct bags and other containers
among the tribes of the Plateau
Region of eastern Washington and
Oregon, Idaho, and western Montana.
The technique consists of laboriously
twining cornhusks around a founda-
tion of native hemp string. The term
"cornhusk" refers to bags and hats
that are made with a twined-
weaving technique overlaid with
false embroidery. In spite of the
difficulty and time involved in such
weaving, it has been utilized in the
area for thousands of years. Oregon
archaeologist Luther Cressman used
carbon-dating techniques to
establish that pieces of twined
basketry found in Catlow Cave in
the deserts of eastern Oregon date
from 7000 B.C. (J. M. Gogol,
American Indian Basketry Magazine
1, no.2, 1980).
Kopp Collection

46.

CORNHUSK BAG
Plateau Indians
Early 20th century
Twine, cornhusk, dyed wool yarns.
l. 9 1/2"; w. 8 3/4"

Although earlier bags with an overlay
of bear grass or other native grasses
on a foundation of native hemp are
commonly called "cornhusk bags,"
the use of cornhusk began in the mid-
nineteenth century. The small size of
this bag indicates that it may have held
personal items such as jewelry, medals,
or fetishes.
Thaw Collection

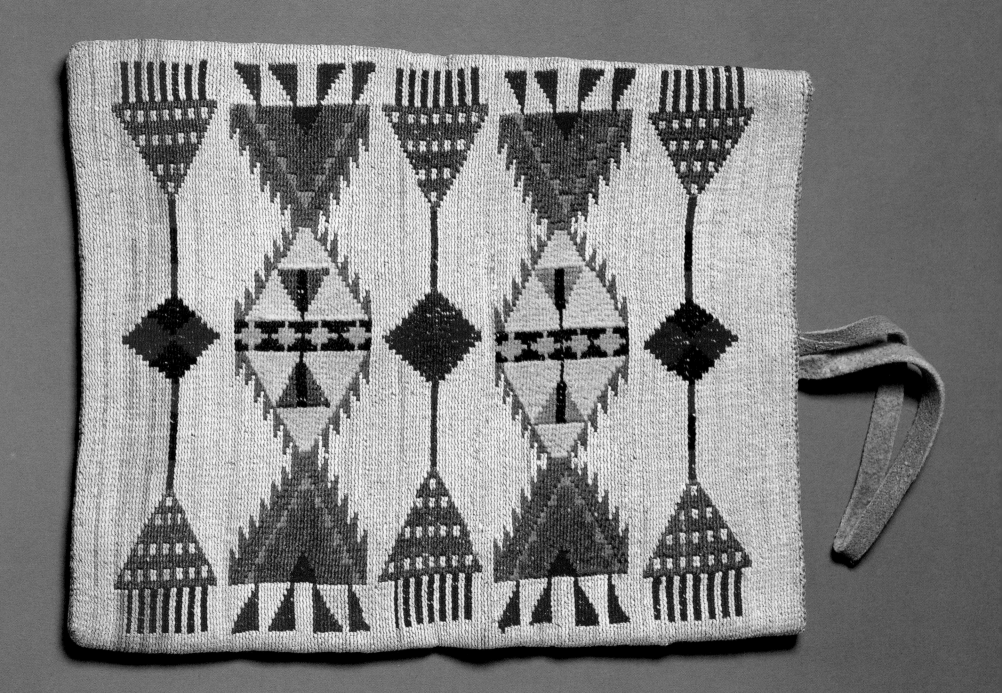

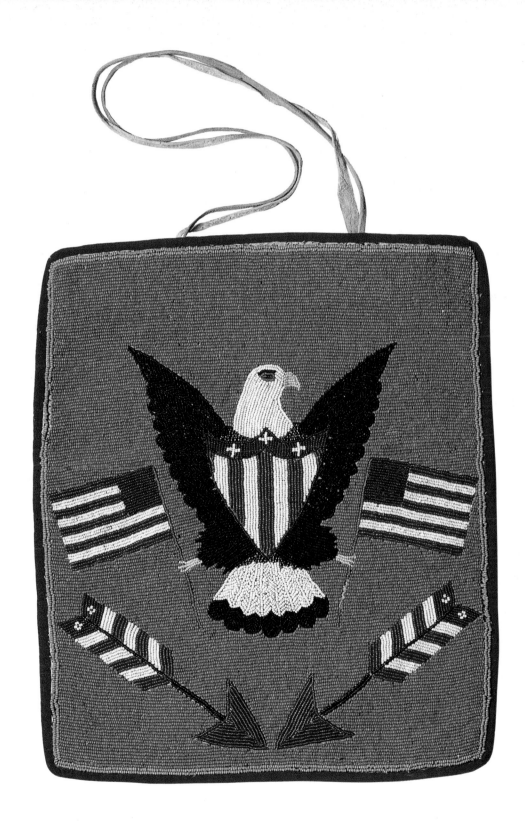

< 47.

CORNHUSK BAG
Plateau Indians
Late 19th to early 20th century
Cornhusk, wool yarn, native hemp.
l. 13 1/4"; w. 10 7/8"
The five-part horizontal pattern is a
traditional design, but the abstracted
triangular flag motif is both original
and unusual.
Kopp Collection

48.

BAG
Plateau Indians
Circa 1920
Native tanned hide, glass beads, cotton binding, felt back.
h. 13 3/4"; w. 11 1/2"
Flat beaded bags were made by the Plateau people from
the late nineteenth century. Used primarily as colorful
decorative accessories for women, the designs often
incorporate floral or figural motifs.
Kopp Collection

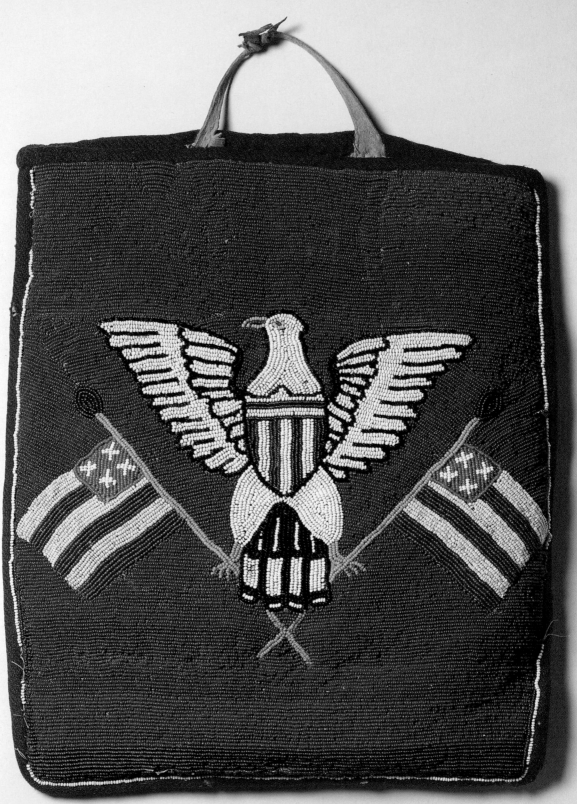

49.

BAG
Plateau Indians
Early 20th century
Native tanned hide, glass beads, red wool
backing, printed cotton lining, one strap
missing, the other broken and tied.
l. 13 1/2"; w. 11 3/4"

Plateau women carried these elaborate
bags to special feasts, giveaways, and
other celebrations, such as the Fourth
of July.
Thaw Collection

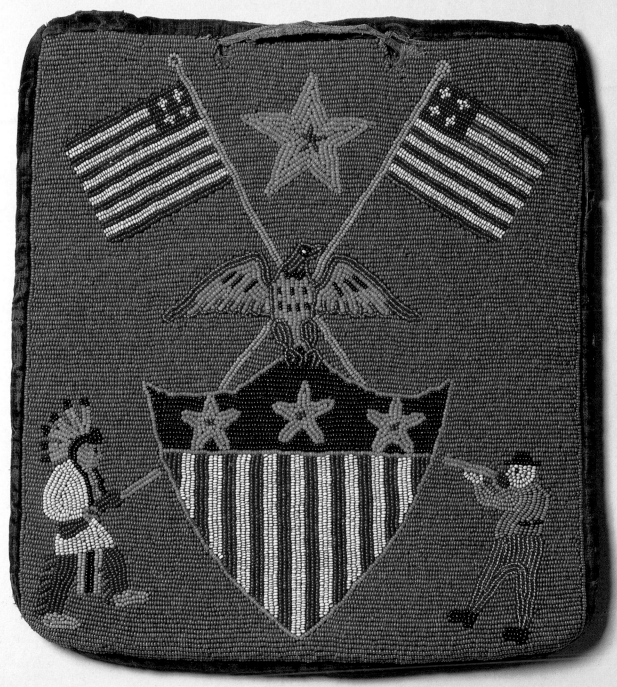

50.
BAG
Plateau Indians
Late 19th to early 20th century
Native tanned hide, glass beads, commercial
cotton cloth binding.
h. 10⁵/₈"; w. 9⁵/₈"; Strap 5¹/₄"

The tableau of cowboys/settlers versus Indians
was acted out innumerable times in real life as
well as in Wild West shows, frontier days, fairs,
and rodeos, and would have been a well-known
scene to the native craftworker.
Kopp Collection

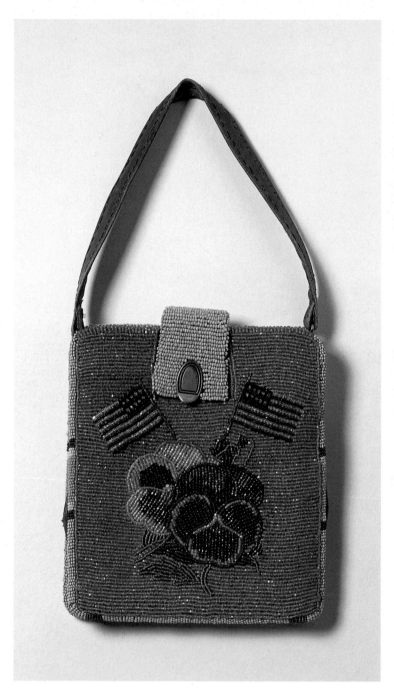

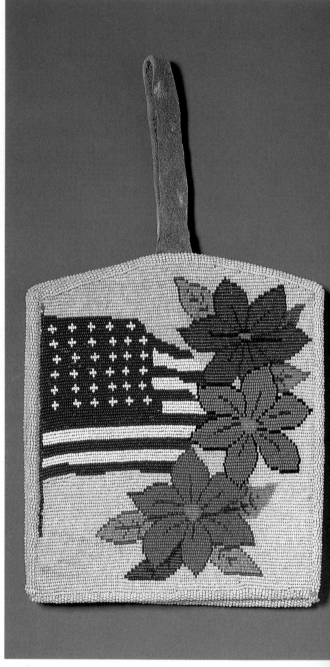

51.
PURSE
Plateau Indians or Crow
c.1925–1950
Commercial leather purse, glass beads.
l. 7^1/$_2$"; w. 6^1/$_4$"

The beaded pansies on the front of the
bag are very reminiscent of ladies'
needlepoint or other "homecraft"
patterns of the twentieth century.
Such a pattern may have inspired the
design on this purse.
Thaw Collection

52.
BAG
Plateau Indians
20th century
Native tanned hide, glass beads, cotton
cloth lining.
l. 9 1/$_4$"; w. 8"

The subject and composition of the
naturalistically waving flag and the brilliantly
colored six-petaled flowers suggest that
some form of advertising, such as a calendar,
may have inspired this design.
Thaw Collection

53. >
BAG
Plateau Indians
Circa 1925–1950
Native tanned hide,
glass beads, cotton
lining, felt back.
h. 12 7/$_8$"; w. 11^5/$_8$";
strap ht. 7 3/$_8$"
Kopp Collection

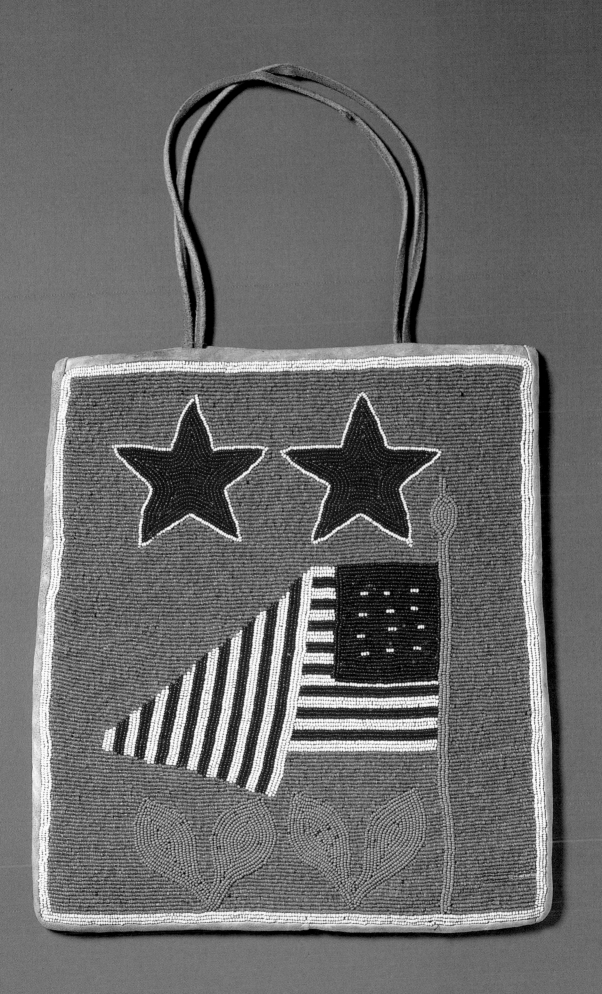

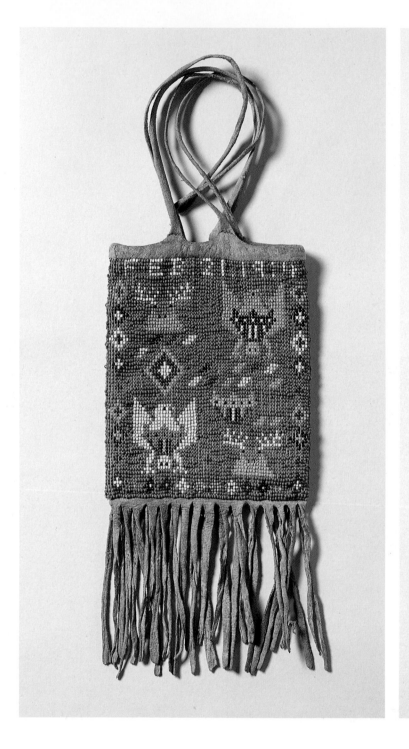
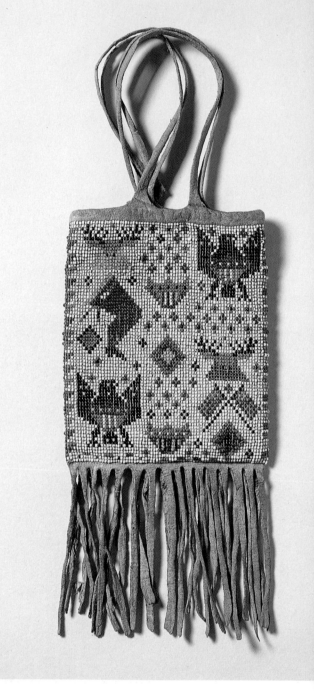

54.

BAG
Wasco or Wishram, Columbia River Valley
Dated "Feb. 21, 1914"
Glass beads, native hemp string, native tanned straps and fringe.
h. 13"; w. 8 ¹/₂"; Strap 10"

This bag is constructed with a cross-stitch, loose-warp beading technique in which the front and back are made as one continuous piece, which is then folded and sewn up the sides. The images—elk, eagles, a woman's leg with a garter, stockings, and high-heel shoes, patriotic symbols—suggest that the bag was made for a man, and the date probably refers to a special occasion.
Kopp Collection

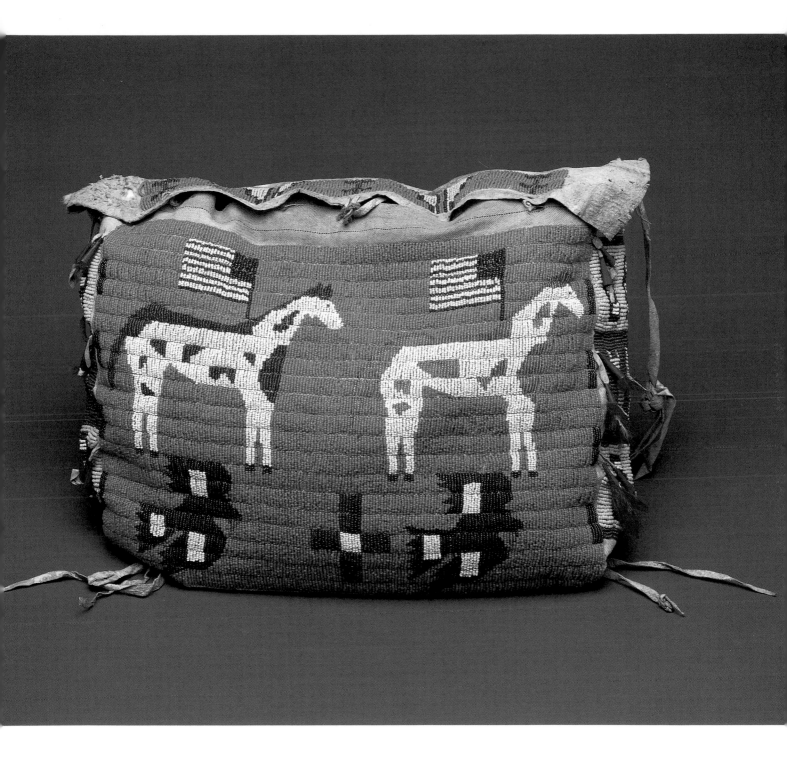

55.

POSSIBLE BAG
Lakota
Late 19th to early 20th century
Cotton canvas, glass beads, tin cones, dyed
feathers.
h. 12"; w. 16 1/2"; d. 4"

Horses, especially pintos such as these, were
very special presents that were traditionally
given on ceremonial occasions. The
American flags appearing above the horses'
backs suggest a Fourth of July celebration.
Kopp Collection

56.

POSSIBLE BAG
Lakota
Late 19th century
Native tanned hide, glass beads, dyed
hair, tin cone wraps.
h. 14"; w. 20"; d. 3"

"Possible bag" was the name given by
early nineteenth-century traders to
these rectangular soft-skin bags. The
term is a direct translation from the
Indian word meaning "a bag for every
possible thing" (Conn 1979, p.152).
A more accurate term might be
storage or tipi bag, as these containers
held personal items and were placed
around the inside of the tipi where
they doubled as pillows. When
moving camp, possible bags were
hung in pairs on either side of a saddle
where their sumptuous decoration
could be admired.

 The elaborate forked diamonds
are typical Lakota design elements.
Kopp Collection

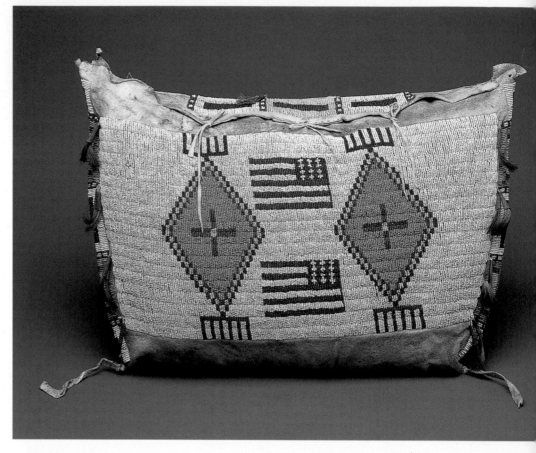

57.

POSSIBLE BAG
Lakota or Nakota
Late 19th to early 20th century
Native tanned hide, glass beads, tin
cones, dyed horsehair.
h. 15 1/4"; w. 21 1/2"; d. 3 1/2"
Thaw Collection

58.>

PARFLECHE SADDLEBAG
Lakota, Standing Rock Reservation,
North Dakota
Circa 1890
Prepared cowhide with native tanned
buckskin fringe, cotton binding,
commercial pigments.
h. 15"; w. 12"; d. 4 1/4"

The geometric design of the flag
lends itself to the traditional abstract
patterns of parfleche decoration. A
closely related example, without the
fringe, is in the South Dakota State
Historical Society.
Collected by Forrest Otis, storekeeper
in Cannon Ball, ND, around 1890.
Thaw Collection

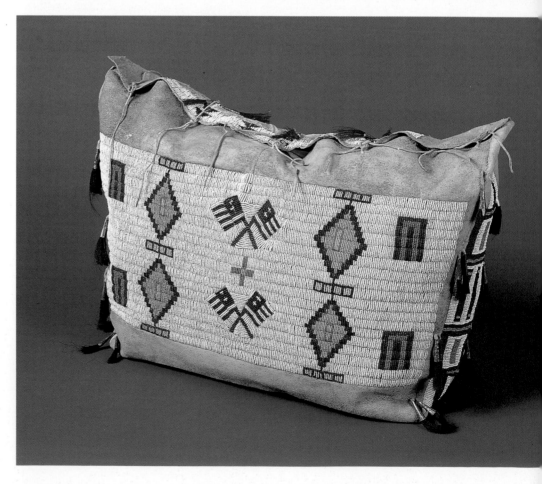

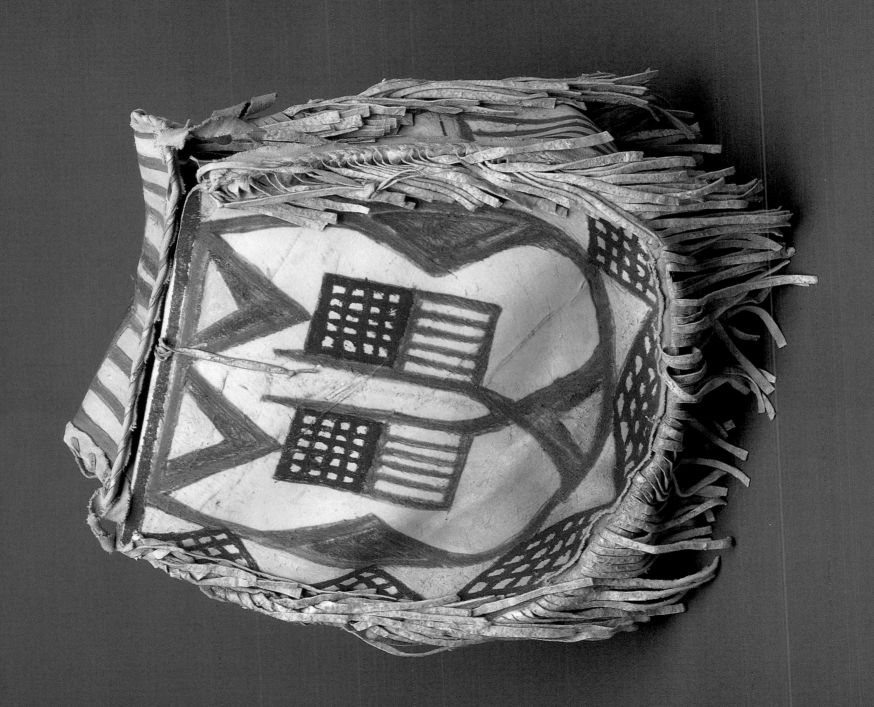

59.

PURSE
Lakota
Late 19th to early 20th century
Manufactured framework and chain,
glass beads.
h. 4"; l. 6"

Commercially made purses and
satchels were used as a foundation for
elaborate bead embroidery.
The beadwork was sewn on tanned
leather which was then fitted to a
commercial metal framework.
Kopp Collection

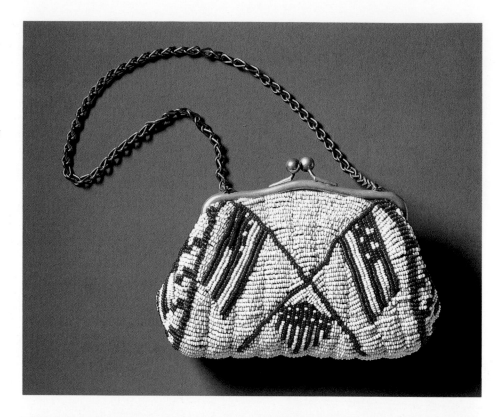

60.

SATCHEL OR CLUB BAG
Lakota
Circa 1900
Commercial leather satchel with metal
clasp and leather handles, glass beads,
cotton lining.
h. with handle $9^1/_2$"; l. 10"; w. 7"

The use of a green background with
American flag beadwork is unusual.
Kopp Collection

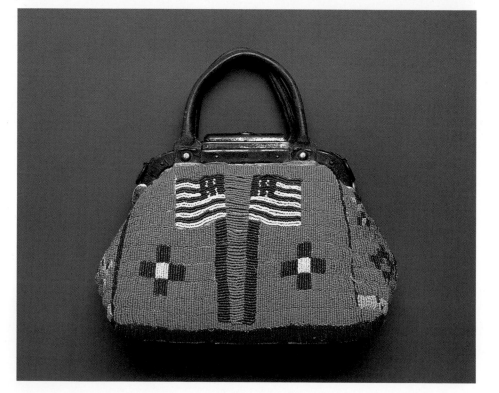

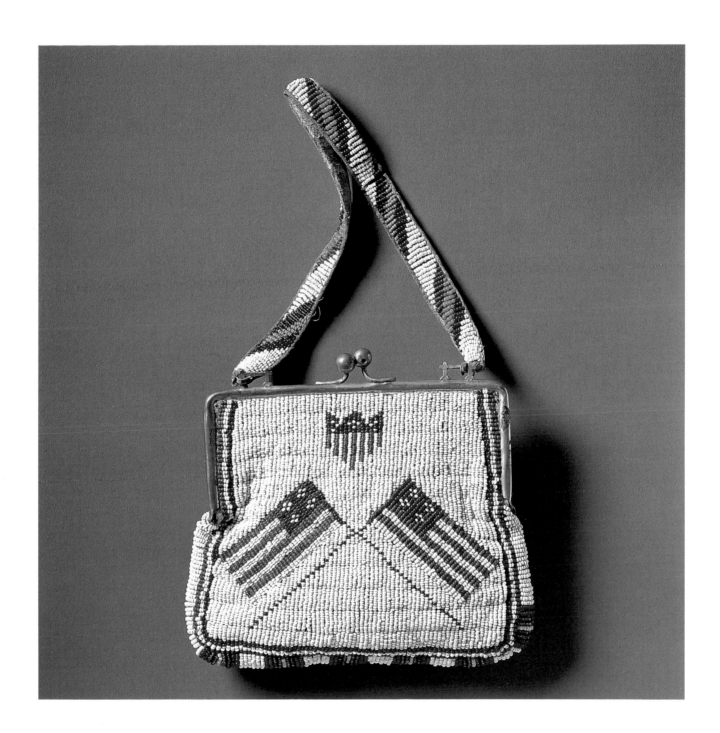

61.

Purse
Lakota
Late 19th to early 20th century
Manufactured framework, glass beads.
h. 6 ½"; l. 7"

The combination of American Indian beadwork
stretched over a commercial frame parallels the
acculturation process that was taking place as part of
the Reservation Policy. Purses such as this may have
been intended for tourists, but it is just as likely that
they were made for American Indian use and proudly
carried by a Lakota woman who thereby showed her
knowledge of the latest Euro-American fashion.
Kopp Collection

62.

SATCHEL OR CLUB BAG
Lakota
Late 19th to early 20th century
Commercially made satchel or bag
covered with a native tanned hide and
glass beads.
h. with handle 9$^{1}/_{2}$"; w. 11$^{1}/_{2}$"; d. 7"

These sturdy, commercial bags were
beaded by American Indian women
for their own use, for gifts, and for
sale to the tourist trade.
Kopp Collection

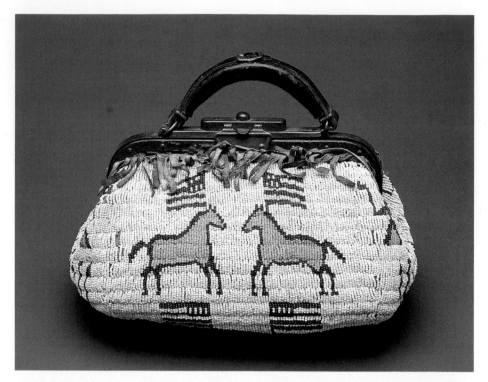

63.

SATCHEL OR CLUB BAG
Lakota
Late 19th to early 20th century
Commercially manufactured frame-
work, native tanned hide, glass beads.
h. with handle 7$^{3}/_{4}$"; w. 12$^{1}/_{2}$"; d.
6$^{1}/_{2}$"

Bags of this design were offered in a
half-dozen or more sizes in the
catalogues of such companies as Sears,
Roebuck and Montgomery Ward from
the 1880s into the early twentieth
century.
Kopp Collection

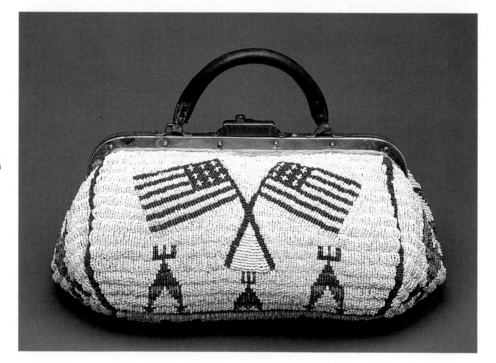

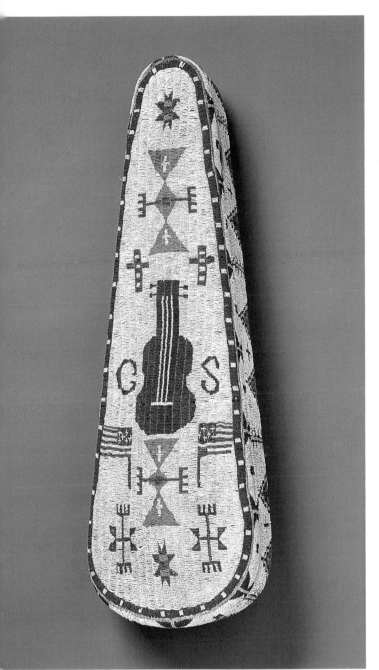

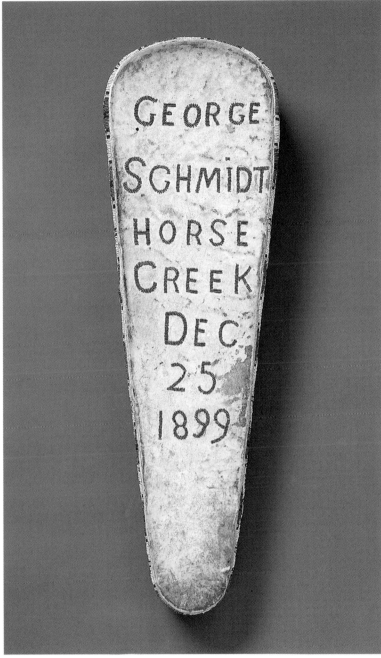

64.

BEADED VIOLIN CASE
Brulé Sioux, Rosebud Reservation, South Dakota
1899
Commercially manufactured wooden violin case covered with native tanned hide to which beadwork has been applied.
h. 31½"; w. 9½"; d. 4½"

This extraordinary piece of flag beadwork poignantly captures the merging of Native American and Euro-American cultures during the Reservation Period in the late nineteenth century. The initials "G" and "S" on either side of the three-stringed violin stand for George Schmidt. His name, address, and the date, December 25, 1899, are worked in beadwork on the back of the case. Schmidt was a German immigrant who married a Brulé Sioux woman and settled in the Horse Creek community, south of White River on the Rosebud Reservation. His descendants are Brulé Sioux and still reside at Rosebud.
Thaw Collection

CHILDREN'S OBJECTS

CLOTHING STILL PLAYS an important role in teaching Native American traditions to children. Special occasions and established ceremonies remain popular opportunities for reaffirming ancestral ties and native identity through traditional clothing. Those items made for children were often more highly decorated than comparable ones for adults, in part because of the smaller size.

Certain clothing forms come from well-established traditions (figs. 67–73). Other clothing utilizes Euro-American forms from the late nineteenth century, but with a decidedly American Indian overlay. Missionaries and government agents actively promoted the adoption of non-Indian clothing, and cowboys, ranch families, and other settlers provided other models (figs. 75–95).

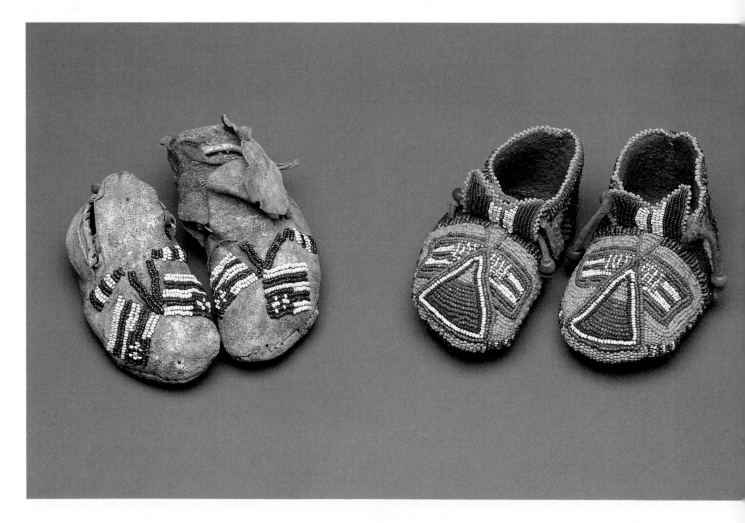

65.
INFANT'S MOCCASINS
Lakota
Late 19th century
Native tanned hide, glass beads.
h. 2"; l. 4³/₈"; w. 2¹/₄"
Kopp Collection

66.
INFANT'S MOCCASINS
Possibly Lakota or Nakota
20th century
Native tanned hide, glass beads.
h. 2"; l. 4¹/₄"; w. 2"

These infant's moccasins have an unusual decoration, which makes tribal identification difficult. Several types of beading techniques are employed. One type, called flatwork, was popular in North Dakota and Montana.
Kopp Collection

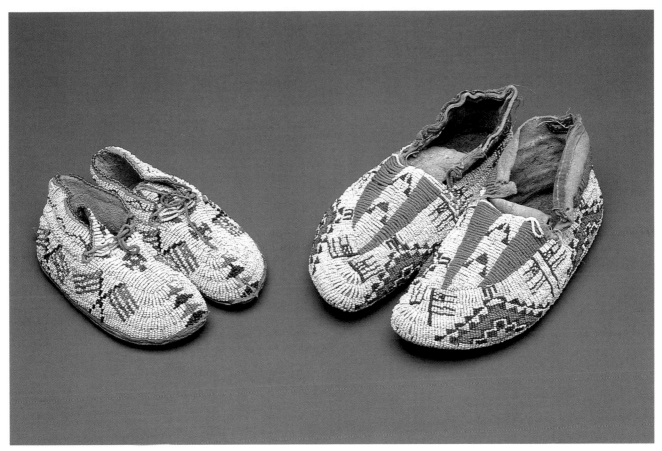

67.
CHILD'S MOCCASINS
Lakota
Early 20th century
Native tanned hide and glass beads.
h. 2 $\frac{1}{2}$"; l. 5 $\frac{1}{2}$"; w. 2 $\frac{1}{4}$"
Thaw Collection

68.
BOY'S MOCCASINS
Lakota
Late 19th to early 20th century
Native tanned hide, glass beads and
commercial cloth edging
h. 2 $\frac{3}{4}$" l. 8 $\frac{1}{4}$" w. 3 $\frac{1}{8}$"

This exquisite pair of fully
beaded moccasins has green
buffalo tracks on the insteps,
elaborate triangles and
American flags on the sides.
Thaw Collection

69.
CHILD'S MOCCASINS
Lakota or Nakota
Late 19th to early 20th century
Native tanned hide, glass beads.
h. 2 $\frac{1}{4}$"; l. 6 $\frac{1}{8}$"; w. 2 $\frac{5}{8}$"

The practice of beading the soles
appears to be a late nineteenth-century
Reservation Period trait (Hail 1980:
111, fig. 63). Even though it was
impractical to walk in such moccasins,
there is ample evidence that many were
made for use.

The beaded soles, which could be
seen when sitting with legs extended or
riding in ceremonial parade, were
certainly an extravagant touch.
Moccasins of this type are also
erroneously called "burial moccasins."
Kopp Collection

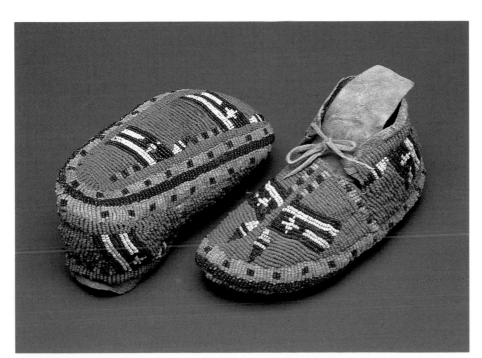

70.
CRADLE
Lakota
Late 19th to early 20th century
Native tanned hide, glass beads,
canvas with red wool covering, printed
cotton interior.
l. 17"; w. 7"; d. 11"

Although cradles of this form with a
fully beaded hood were used by
American Indians of the central Plains,
especially the Lakota (Hail 1980:
144), examples of this size were made
as toys or as souvenirs for early
collectors.
Thaw Collection

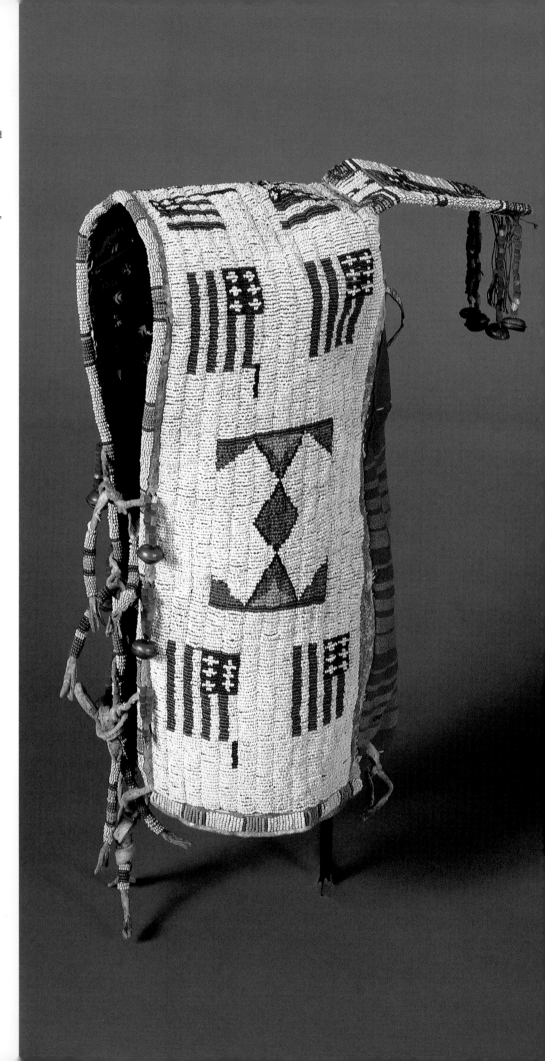

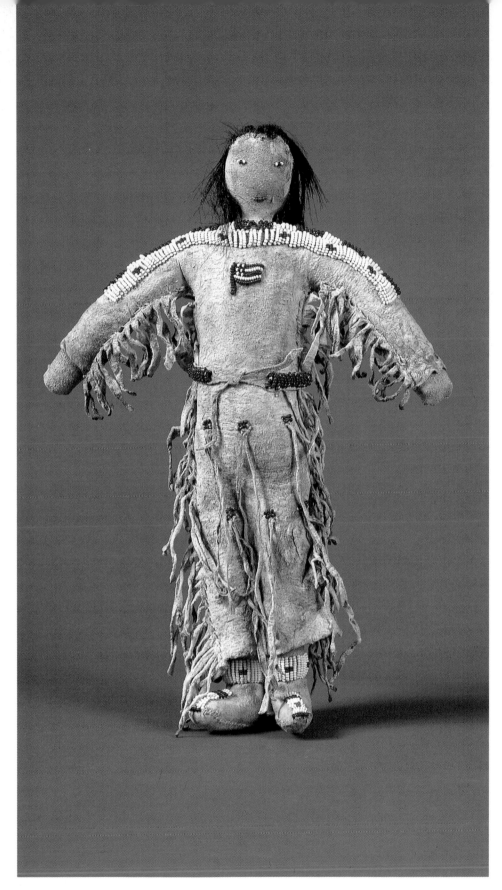

71.
DOLL
Lakota
Late 19th to early 20th century
Native tanned hide, glass beads,
human hair.
h. 12 7/8"; w. 9 1/4"

American Indians made dolls for
religious reasons as well as for
children's play. An American flag
such as this one, beaded on the
front, is an extremely unusual motif.
Thaw Collection

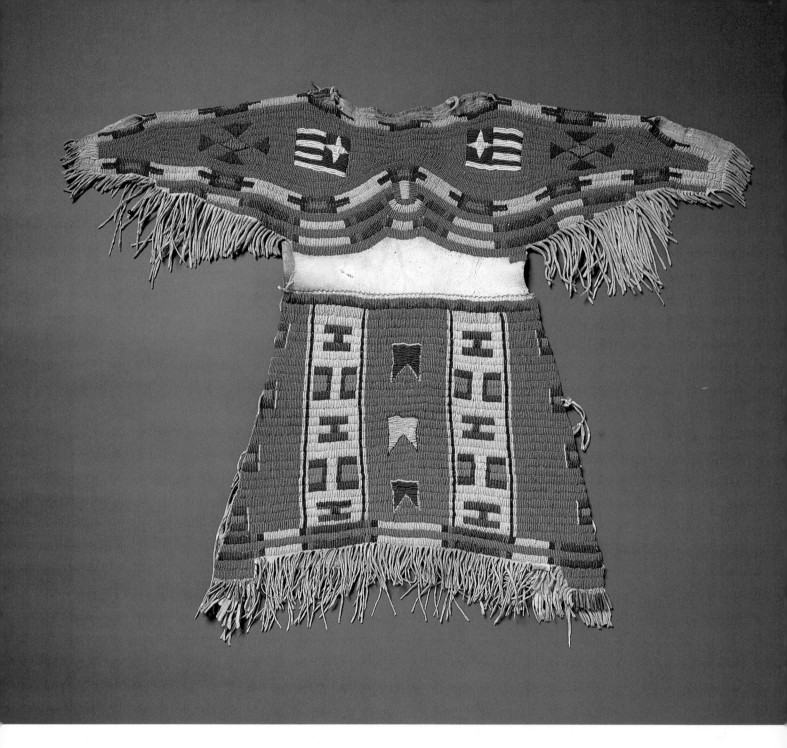

72.

CHILD'S DRESS
Lakota or Nakota
1880–1890
Native tanned hide, glass beads and tin cones.
l. 27"; w. 22"

The blue background, color choices, bold
designs, and refined execution suggest a northern
manufacture and a date early in the 1880s. The
four-pointed Morning Star, a traditional symbol
of visions and rebirth, replaces the typical five-
pointed star in the American flag and may
represent a conscious attempt on the part of the
artist to reconcile traditional beliefs with the new
order imposed by the U.S. government during
the Reservation Period.
Thaw Collection

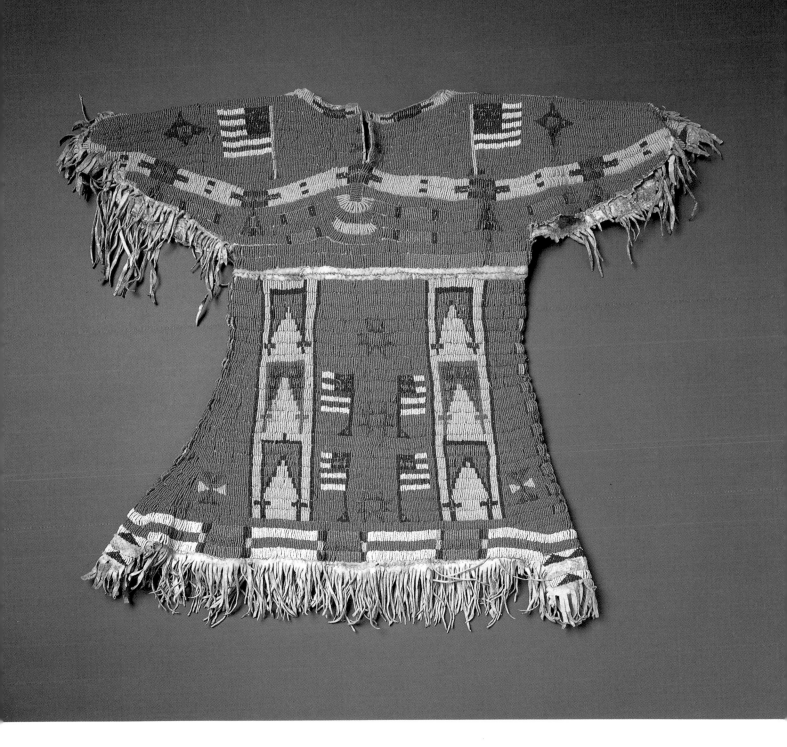

73.
GIRL'S DRESS
Lakota or Nakota
1880–1890
Native tanned hide, glass beads.
h. 24"; w. across arms 30"

This dress is so similar to plate 72 that
they were possibly made by the same
maker or related makers from one
family.
Kopp Collection

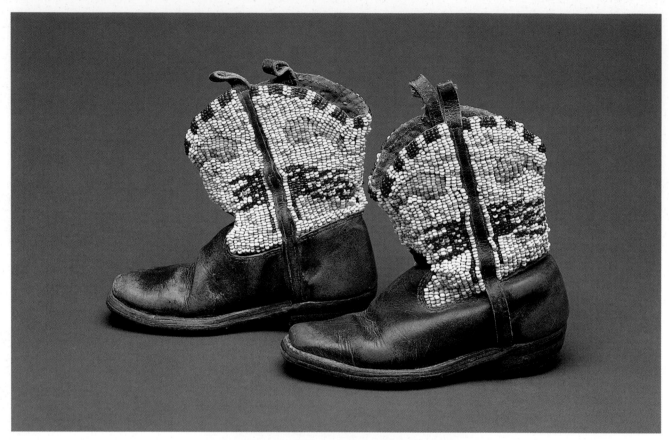

75.

CHILD'S COWBOY BOOTS
Lakota
Early 20th century
Commercial leather, glass beads.
h. 6 ½"; l. 6"; w. 2 ½"

This pair of child's cowboy boots has
been adapted to American Indian taste
by the addition of beadwork on the
upper portions.
Thaw Collection

74.

KNIFE AND BEADED KNIFE SHEATH
Lakota
Early 20th Century
Sheath: native tanned deerhide, glass
beads, cloth strips.
Knife: metal blade, native tanned
deerhide handle.
h. 7"; w. 2 ⅛"

This knife and sheath was made for
a boy named "Sam Baer" or more
probably, Bear.
Thaw Collection

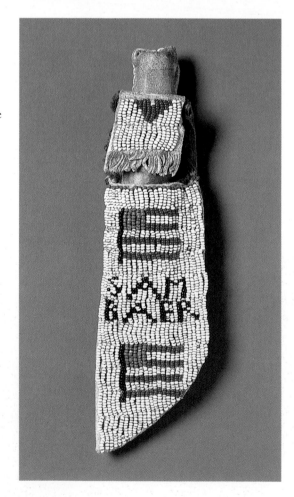

76.>

GIRL'S CAPE
Lakota
Late 19th to early 20th century
Native tanned hide, glass beads, cloth
binding, button missing.
h. 22"; w. 36 ½"

Capes gained popularity among
American Indians toward the end of
the nineteenth century, although it
is not known whether there is any
relationship between painted capes
made for men and beaded pictograph
examples made for girls. Drawings by
Amos Bad Heart Bull of the Oglala
(Blish 1967: pp. 205, 292, 326, 349,
388, etc.) and Standing Bear of the
Minneconjou (Maurer 1992:199, fig.
155) depict warriors with capes. Often
the decoration included painted
images similar to those seen on shields
as part of the owner's personal
"medicine." Historic photographs also
show girls wearing capes as a Victorian
fashion accessory. The girl's cape in
the Kopp Collection shows a
profusion of images, some of which—
stars, buffalo heads, and long-tailed
birds—may relate to images received
in visions, while others—chickens,
striped dogs, and spotted cats—are
more whimsical. The flags are
rendered with horizontal stripes on
one half and vertical on the other.
Kopp Collection

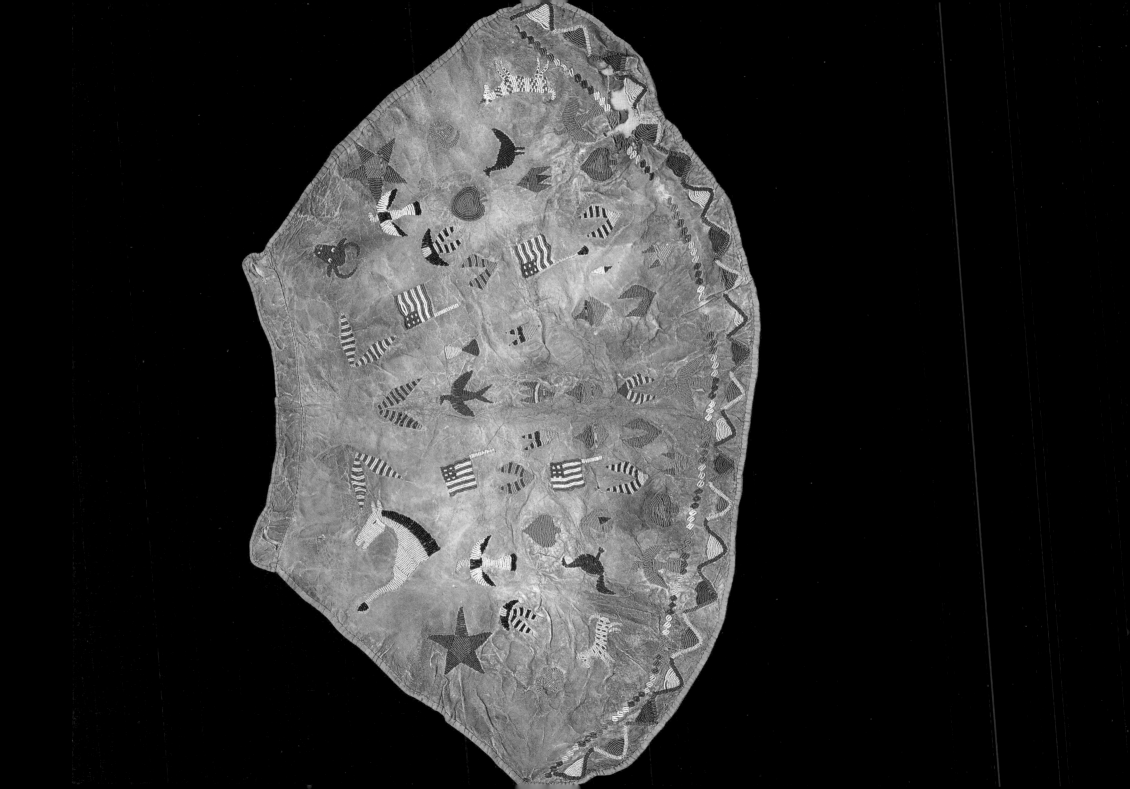

77.
BOY'S CAP
Lakota
Early 20th century
Canvas, glass beads, printed cotton
lining.
h. 2 ½"; w. 9 ¼"; d. 7"

The beaded surface of the cap
is uneven because each thread is
crowded with individual beads.
Thaw Collection

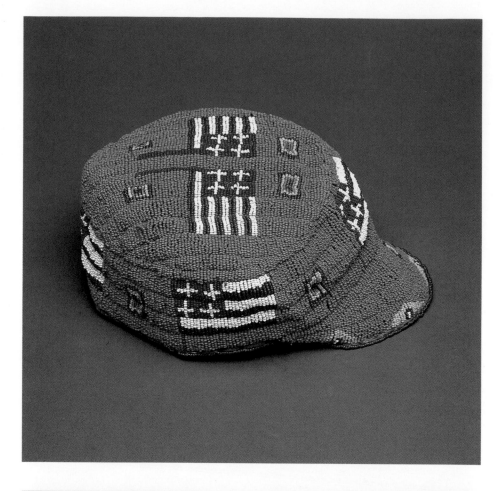

78.
BOY'S CAP
Lakota or Nakota
Early 20th century
Native tanned hide, glass beads,
cotton lining.
l. 8 ¾"; w. 5 ½"; h. 3"

The form imitates popular Euro-
American boys' caps of the late
nineteenth century.
Kopp Collection

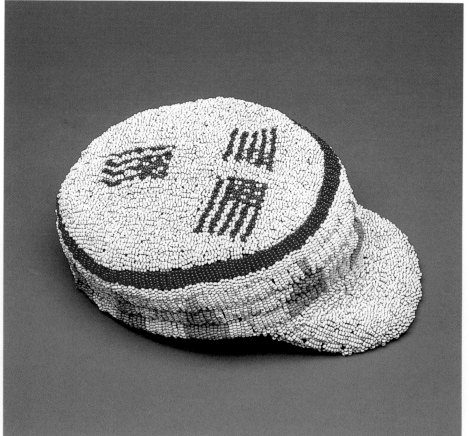

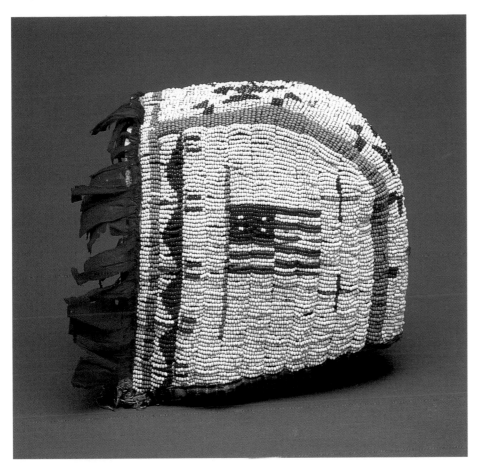

79.
BABY BONNET
Lakota
Late 19th to early 20th century
Native tanned hide, glass beads, silk
fringe, ribbon ties missing, calico
lining.
h. 6¼"; d. 7¼"

Although the baby bonnet was
adopted from Euro-American
prototypes, the rich beadwork is
Lakota in concept. Such decoration
reflects the love and attention given
to children as well as the individual
family's wealth and status. Although
this may be unintentional, the single
bold flags worked on each side are
shown at half-mast.
Thaw Collection

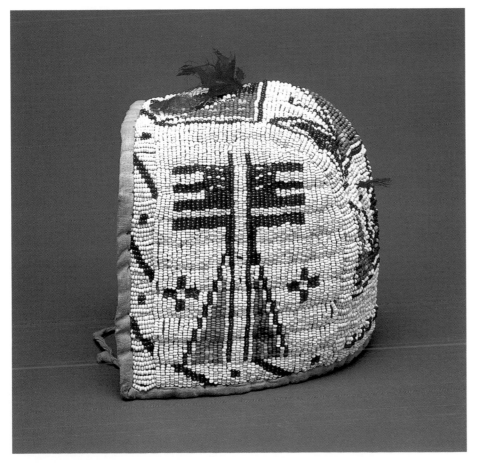

80.
BABY BONNET
Lakota
Late 19th or early 20th century
Native tanned hide, glass beads, silk
ribbon, linen with c. 1890 printed
calico cotton ties.
h. 6¾"; d. 5"

A complex triangle, a favorite Lakota
motif, surmounted by two American
flags is on each side of the bonnet.
Kopp Collection

81.
BABY BONNET
Lakota
Late 19th to early 20th century
Native tanned hide, glass beads,
hide strap.
h. 7"; d. 5½"
Kopp Collection

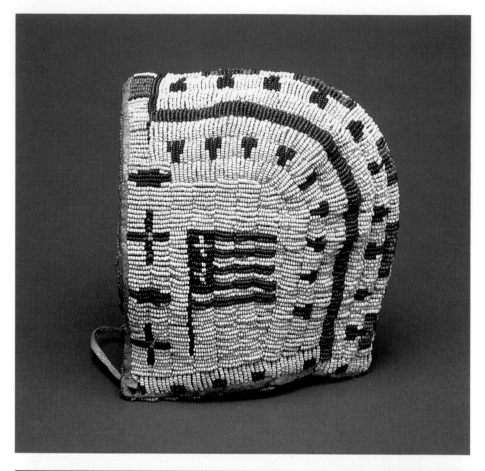

82.
BABY BONNET
Lakota
Late 19th to early 20th century
Native tanned hide, glass beads,
cotton binding.
h. 5"; d. 4½"

The maker has designed the blue
cantons in a vertical format with four
white blocks representing stars.
Kopp Collection

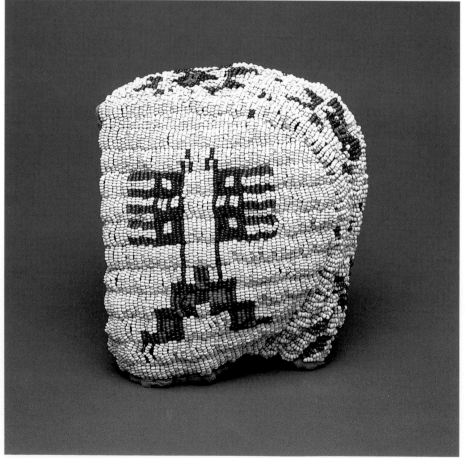

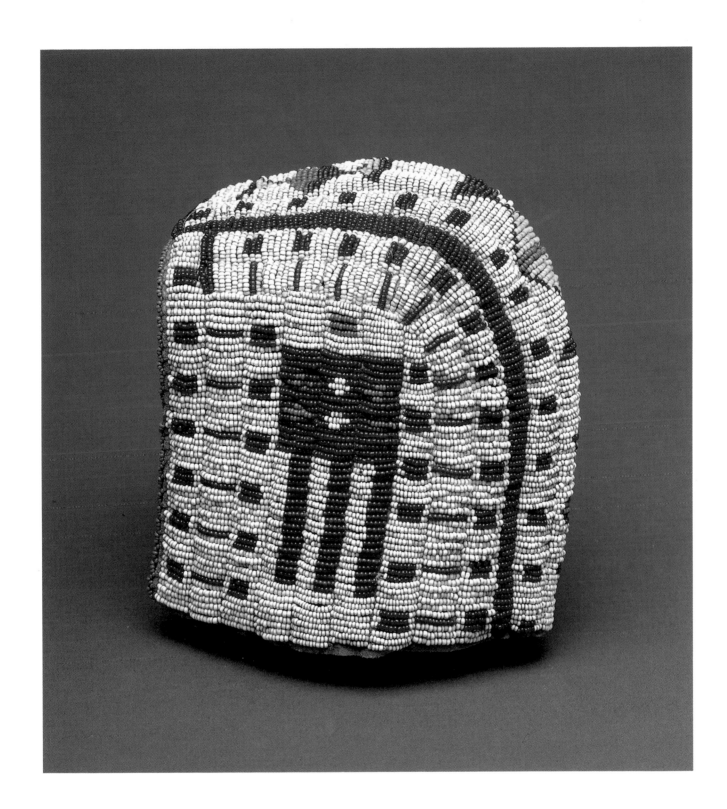

83.
BABY BONNET
Lakota
Late 19th to early 20th century
Native tanned hide, glass beads.
h. 6 1/2"; w. 6"

An unusual combination of green
and white stars marks this depiction
of the flag.
Kopp Collection

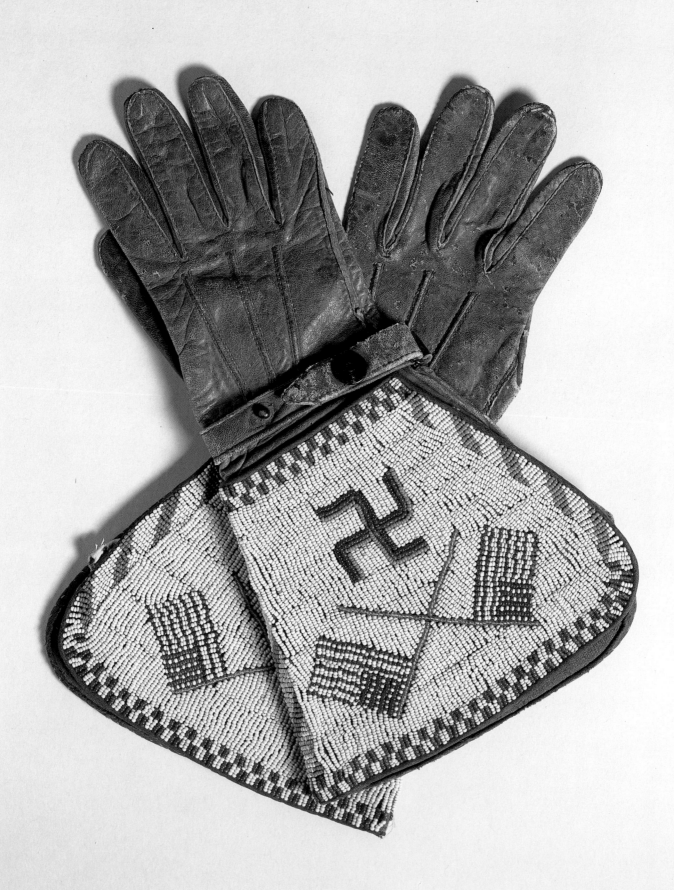

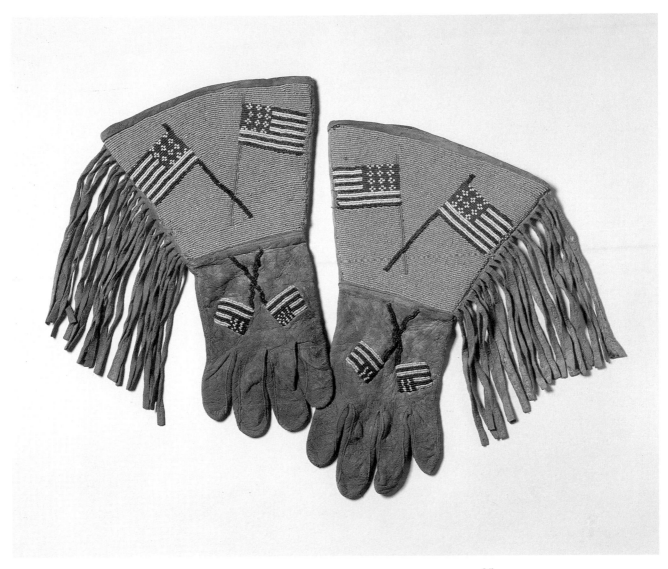

84.

BOY'S GAUNTLETS
Lakota
Early 20th century
Commercially made gloves, glass beads.
l. 12 1/4"; w. 6 3/4"

The swastika design, a four-directional
cross with the ends of its arms bent to
show movement, is a traditional American
Indian symbol. Despite its present-day
connotations, the design predates Hitler's
Nazism by many centuries.
Thaw Collection

85.

BOY'S GAUNTLETS
Plateau Indians
Late 19th to early 20th century
Commercially made gloves, glass
beads.
l. 11"; w. 7 1/8"

Gloves copied from U.S. cavalry
gauntlets became popular clothing
items across the United States by the
turn of the century.
Thaw Collection

Figure 10. "Hezekiah Ezekiel"
Unknown photographer

*This photograph was found inside one of
the gauntlets illustrated in plate 85. The
large gauntlets were probably made for
an adult relative, but the boy may be
Hezekiah Ezekiel, the name written in
pencil on the back of the photograph.*

86.
Boy's Vest
Lakota
Late 19th to early 20th century
Native tanned hide, glass beads,
cotton lining.
l. 14"; w. 14"

Although not further identified,
"George" probably refers to the
original American Indian owner.
Kopp Collection

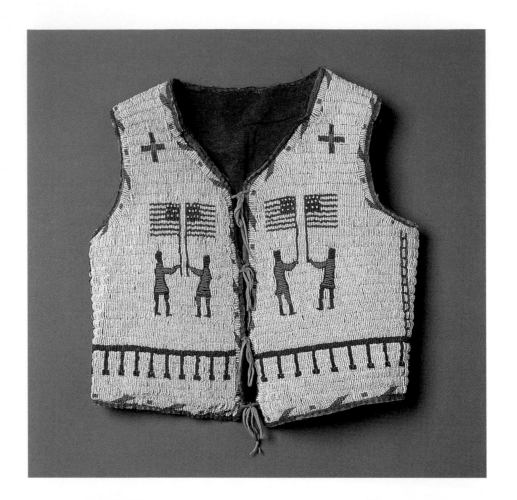

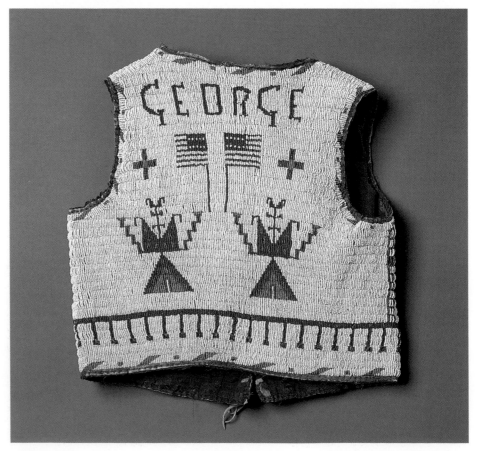

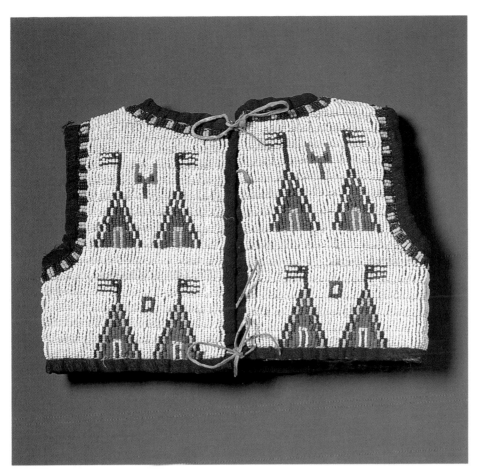

87.
INFANT'S VEST
Lakota
Late 19th to early 20th century
Native tanned hide, glass beads, cloth binding.
h. 7"; w. 10"

Made for a very small infant, the vest came from the collection of a Lakota woman named Hoop Carrier.
Kopp Collection

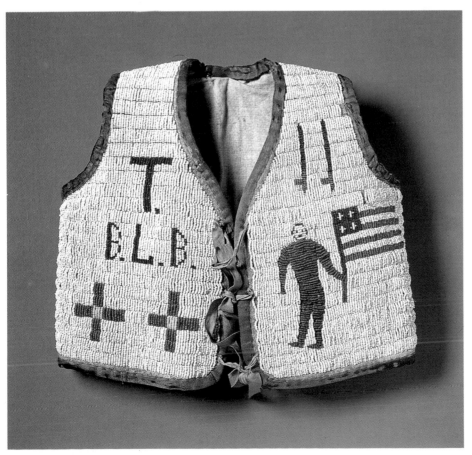

88.
BOY'S VEST
Lakota
Late 19th to early 20th century
Native tanned hide, glass beads, velvet trim, silk ties, cotton lining.
h. 11"; w. 12"

The unusual asymmetrical design includes the initials of the original owner and two pipes, possibly denoting a pipe holder or council member in the family.
Kopp Collection

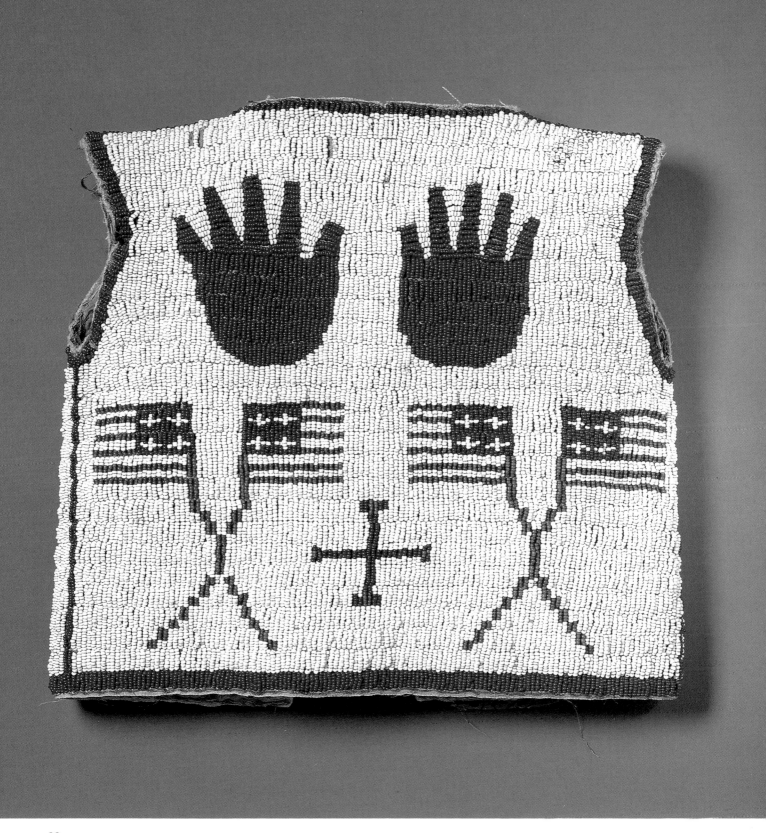

89.

BOY'S VEST
Lakota
Late 19th to early 20th century
Canvas, glass beads, cotton cloth
lining and binding.
h. 10 ½"; w. 11"

The elaborate decoration illustrates the wealth
and time that Lakotas lavished on their
children. The Lakota preference for the num-
ber four, symbolizing harmony and balance, is
suggested by the four flags with four crosses,
and the cross representing the four directions.
The two hands on the back is a reference to
war and bravery (Maurer 1992: 236). On the
front the hands are replaced by stars.
Thaw Collection

90.

CHILD'S VEST
Otoe-Missouri, Nebraska
Circa 1895
Indigo-dyed woolen trade cloth with
selvage border, glass beads, paillettes,
cotton lining.
h. 13 1/2"; w. 14 1/4"

This unusual child's vest is decorated
with the symbols of a revitalist
religious movement founded by an
Otoe-Missouri, William Faw-Faw
Waw-no-she in the 1890s (Wooley
1988, 36–7). In many ways the Faw-
Faw movement was similar to the
Ghost Dance of the same period. It
advocated a series of prescribed dances
and rituals and promised a return to
traditional Indian ways and values by
causing the white man to disappear.
An almost identical vest is worn by
an Omaha, George Biddle, who was
photographed by F.A. Rinehart in
1898 (Grinnell 1904, opp.104).
Thaw Collection

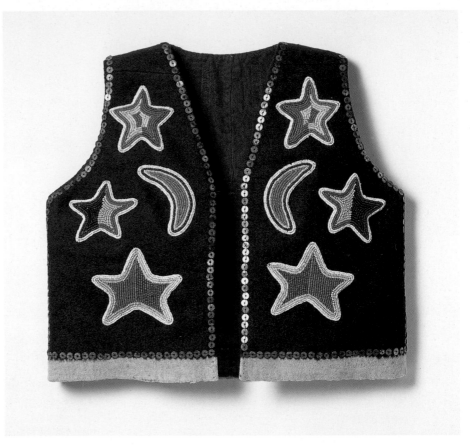

91. OPPOSITE >

VEST
Lakota
Late 19th to early 20th century
Native tanned hide, porcupine quills,
silk ribbons, black silk binding, check
lining, brass beads on leather ties.
h. 13"; w. 12 1/2"

The images of the elk, stylized flags,
and serrated staff retain their original
brilliancy. The vest appears never to
have been worn or exposed to light.
Kopp Collection

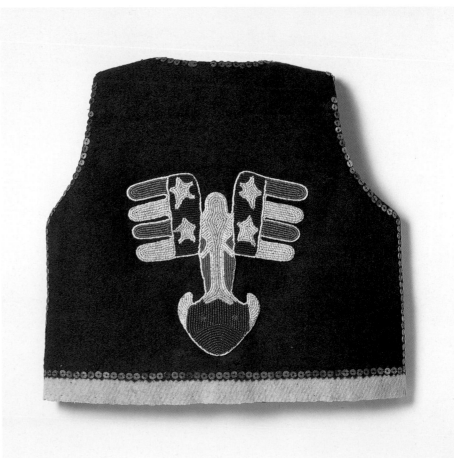

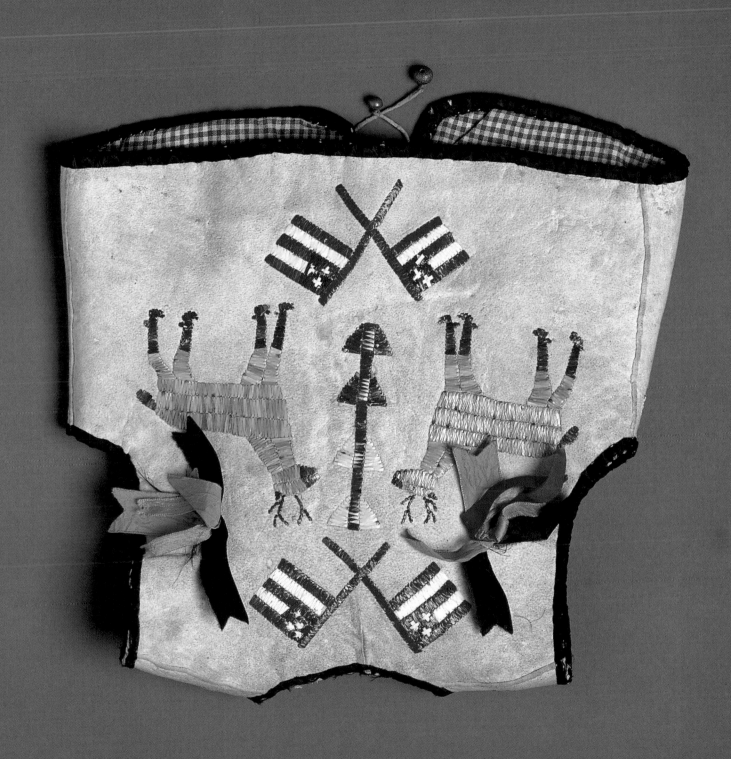

92.

BOY'S VEST
Lakota
Late 19th to early 20th century
Native tanned hide, glass beads,
cotton binding, printed calico lining.
h. 12 ¾"; w. 12"

The symmetrical design incorporates
multiples of four, a sacred number
among the Lakota. The repetition of
four—four stars in all four flags, four
red stripes in the smaller flags, four
white stripes in the larger flags and
two crosses of the four directions—
may be either intentional or an
attempt to balance the composition.
Kopp Collection

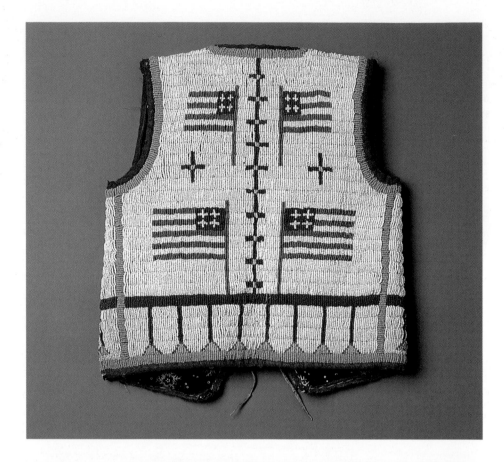

93.

UNFINISHED VEST BACK
Lakota
Late 19th to early 20th century
Native tanned deerskin, dyed
porcupine quills.
l. 10"; w. 9 ½"

The pencilled outline of the design
pattern is still visible on this unfinished
quillwork back panel of a child's vest.
Thaw Collection

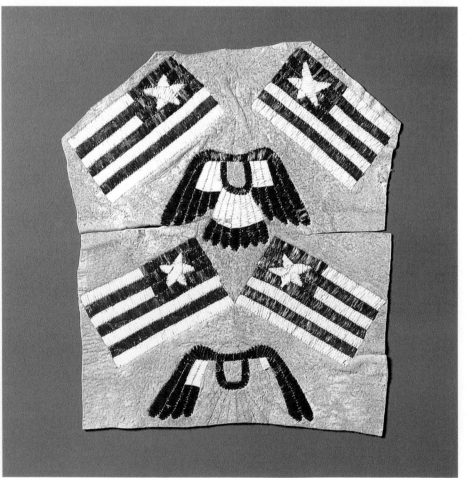

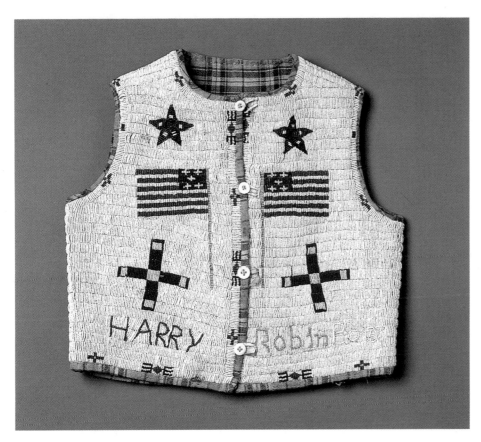

94.
BOY'S VEST
Lakota
Late 19th to early 20th century
Native tanned hide, glass beads, calico
lining.
h. 15 ¹/₂"; w. 16"

"Harry Robin Bow" is written on the
front of the vest, "Bow" rendered in
white beads. On the back, each horse
has a "J:" brand , the significance of
which is now lost.
Kopp Collection

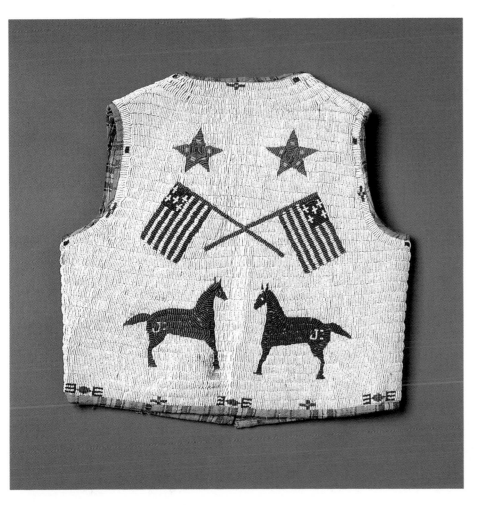

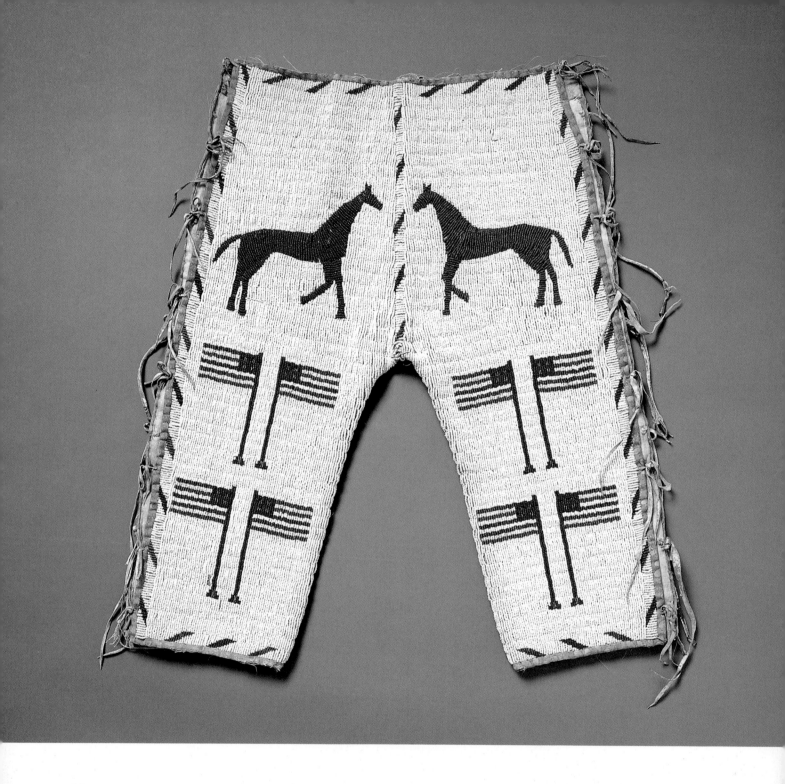

95.
BOY'S TROUSERS
Lakota
Circa 1890-1910
Native tanned hide, glass and metal beads,
quillwork ties, calico binding, cotton grain
or flour sack lining.
l. 22$^{1}/_{4}$"; Waist 27"

Images of horses are traditional symbols of
wealth or, in a child's case, the potential for
wealth. These trousers are fully beaded on
both sides and reflect an extraordinary effort
by the maker.
Thaw Collection

96. >
CHILD'S SADDLE
Lakota
Late 19th to early 20th century
Commercial saddle covered with glass beads applied
to native tanned hide, native hide fringe, tin cones
with dyed horsehair, commercial cloth binding.
h. 30$^{1}/_{2}$"; w. 16$^{1}/_{2}$"; d. 11"

A fully beaded child's saddle illustrates the degree to
which decoration was lavished upon children's
objects in Plains culture. The flags on the stirrup
covers suggest the saddle's use in Fourth of July
parades and celebrations.
Thaw Collection

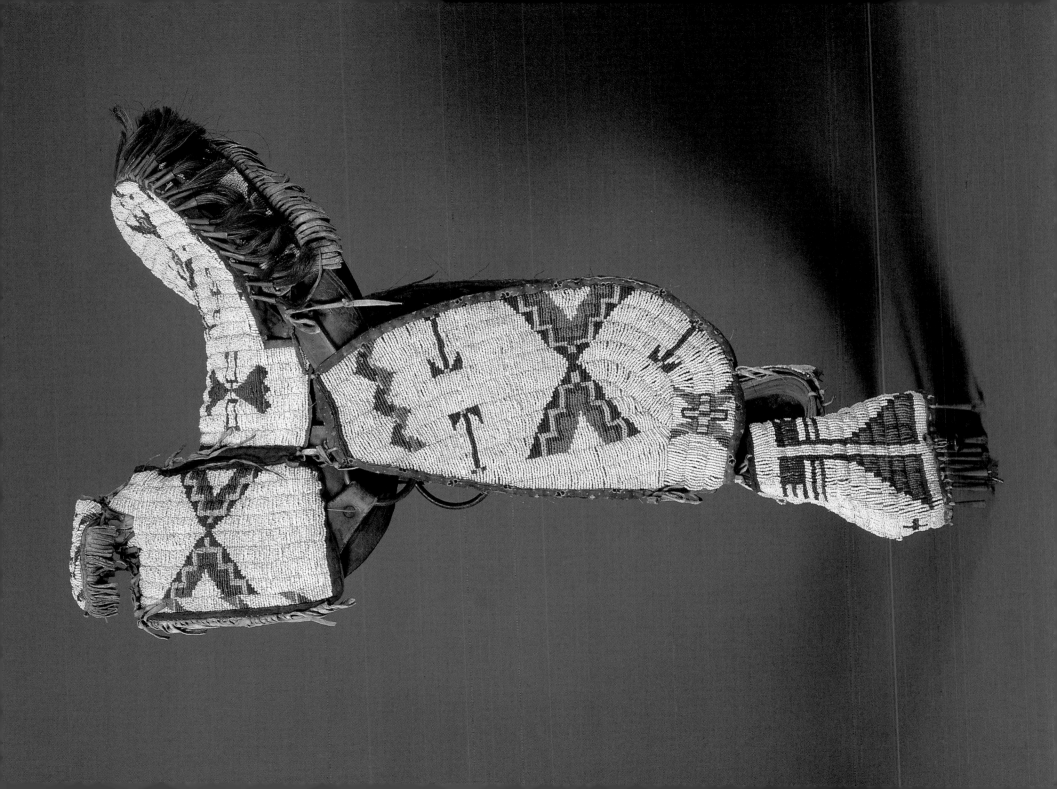

MADE FOR SALE

AMERICAN INDIAN CULTURE maintained a barter economy and, as a consequence, many possessions were used for gifts or trade to other peoples through an age-old inter-tribal system. During the nineteenth century, however, as the traditional ways of life were being curtailed by federal laws and resettlement programs, some tribes began to produce specific items for sale to non-Indians, in particular to the growing tourist market. These objects vary in shape from traditional American Indian forms to souvenirs in the most contemporary taste. Often the production was promoted by a non-Indian who knew both the Euro-American market and also the unique abilities of particular craftspeople.

98.

OLLA
Apache
Late 19th to early 20th century
Willow, devil's claw seed pods, yucca root.
h. 7"; w. 6"

This vase-shape basket is often called an *olla*, a Spanish word for water vessel. Some Apache basketry is woven so tightly that it does hold water, but pitch was usually added as an additional watertight measure. This miniature olla is decorated with American eagles and shields around the top of the neck, and with men and swastikas around the base. The swastikas, or "Whirling Logs," were an ancient American Indian symbol that was discontinued on Apache basketry after 1942.
Kopp Collection

97. >
TRAY
Apache, San Carlos, Arizona
Early 20th century
Willow, devil's claw seed pods, yucca root.
h. 3 1/4"; d. 17 3/4"

Beautifully abstracted American flags bear an uncanny resemblance to weeping willow trees in early nineteenth-century folk art.
Thaw Collection

99.

OVAL BASKET WITH LID
Makah, Washington State
Late 19th to early 20th century
Cedar bark, bear grass, aniline dyes
h. 3³/₄"; l. 6³/₄"; d. 4¹/₄"

The Makah are members of the Salish/Wakashan linguistic group, which includes most of the coastal people of the lower portion of the Pacific Northwest. Because of their proximity to Seattle, these people engaged in a brisk business of selling native crafts to neighboring Euro-Americans. The baskets have a cedar bark warp foundation with a warp-twined decoration.
Thaw Collection

100.

OVAL BASKET WITH HANDLE
Makah, Washington
Late 19th to early 20th century
Cedar bark, dyed bear grass
(xerophyllum tenax).
h. 3⁷/₈"; l. 11³/₄"; w. 5¹/₂"
Thaw Collection

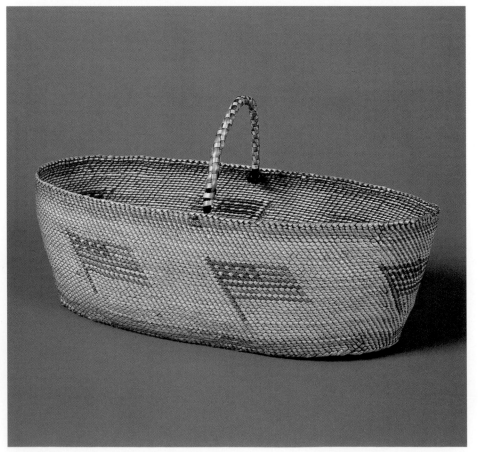

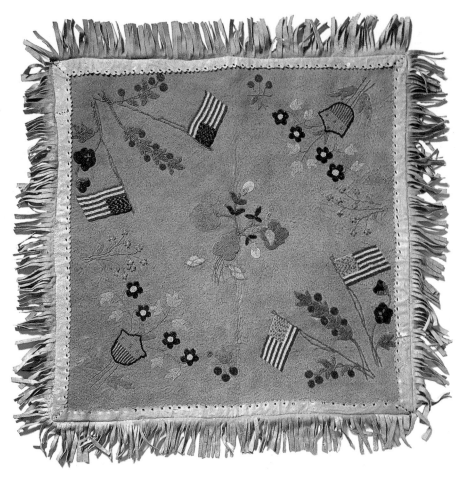

101.

PILLOW SHAM
Han, Northern Athapaskan
Circa 1915
Native tanned moose hide, caribou
fringe and edging, glass beads, glazed
cotton backing.
h. 29"; w. 27"

By 1900 there were three popular
tourist routes in Alaska: two went along
the coast to Skagway or Port William
Sound; the third went inland from
Skagway through Dawson and Eagle to
Nome. Beaded-hide artifacts with
American and Canadian flag designs
were produced by the Subarctic tribes
from the turn of the century. A similar
pillow sham has "Eagle" and "Alaska"
stitched on the front, and may have
been made by the same person (Mastai
1973: 97). Eagle is located on the
Yukon River near the Canadian border
and was one of the prime tourist stops in
Alaska at the turn of the century.
Thaw Collection

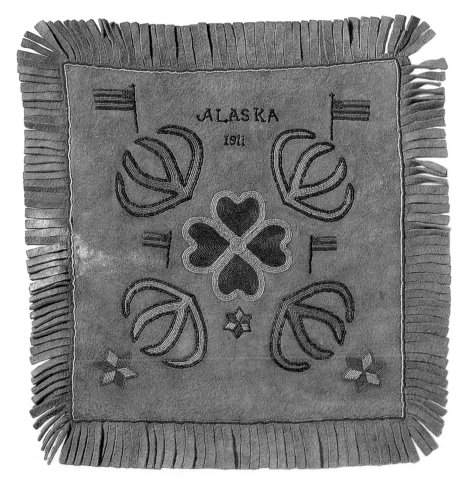

102.

PILLOW SHAM
Han, Northern Athapaskan
1911
Smoked hide, metal and glass beads.
h. 22"; w. 21"

Handmade pillow shams worked in
individualistic designs and materials
became popular household items in
the late nineteenth century. Beaded-
hide covers would have been ideal for
rustic lake or hunting cabins, as well
as a conspicuous souvenir from an
Alaskan trip.
Thaw Collection

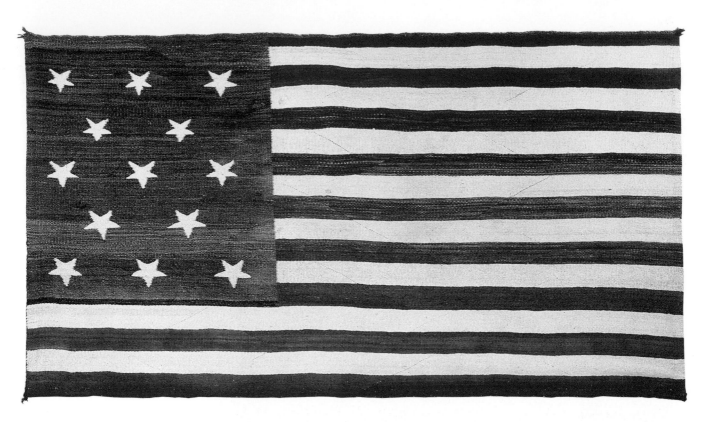

103.
BLANKET
Navajo
Circa 1900
Handspun wool.
h. 52"; w. 94"

In contrast to Lakota beadwork and, possibly, the Plateau cornhusk bags, most of the flag art from other tribes was made purely for Euro-American consumption. Navajo rugs with flags were woven for the tourist trade, and although Navajo weavers took great pride and pleasure in their work, the product always was intended for sale or exchange.
The maker of this blanket created a strong flag image while retaining the shape and size of the traditional Chief's blanket.
Kopp Collection

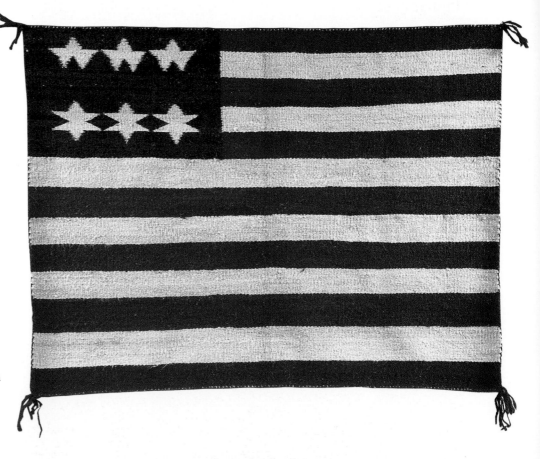

105.
RUG
Navajo, Shonto Trading Post, Arizona
Circa 1930 - 1940
Handspun wool.
l. 40"; w. 52"

The original label reads, "Shonto Trading Post/Western Navajo Agency/Arizona Price $6.00." The unusual stars on the top row resemble stylized swallows; those below are equally eccentric.
Kopp Collection

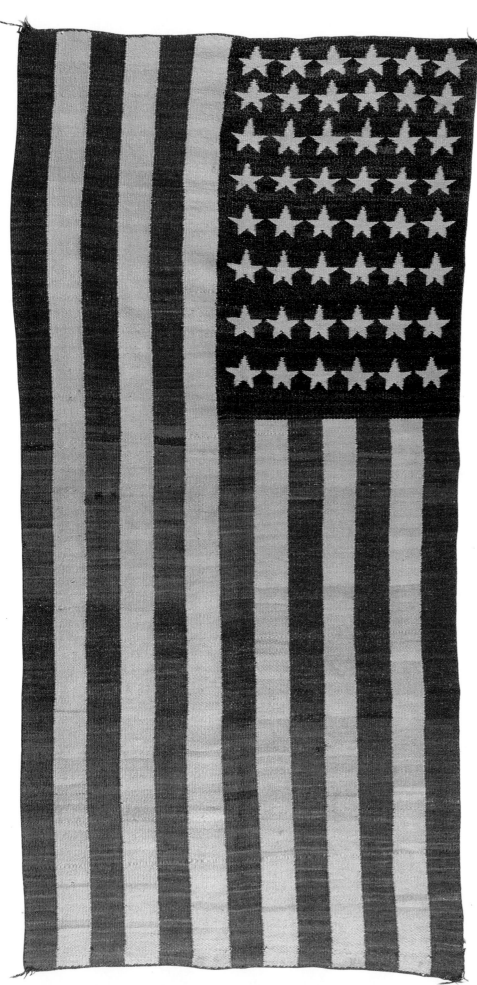

104.
FLAG WEAVING
Navajo
Circa 1920
Handspun wool.
h. 41½"; w. 86"

A close rendition of the American flag,
this weaving was probably made soon
after the admission of Arizona to the
union in 1912.
Kopp Collection

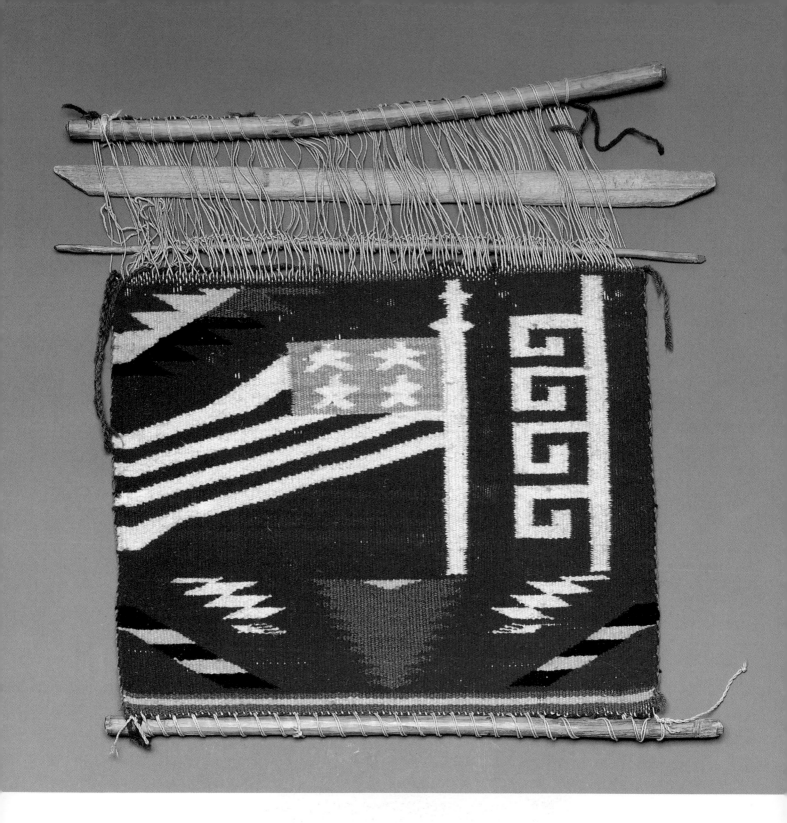

106.

FLAG SAMPLER ON LOOM
Navajo
Circa 1885
Germantown wool.
h. 19"; w. 17"

The image of a flag unfurling in the
breeze is rare in Navajo weavings as are
samplers from this period, which were
made specifically for the tourist trade.
Kopp Collection

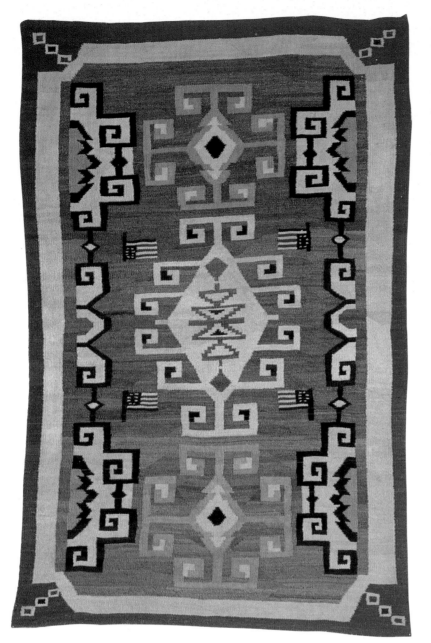

107.
RUG
Navajo, Crystal Trading Post, Arizona
Circa 1920–1940
Handspun wool
l. 65½"; w. 41"

The small flags are an unusual
addition to a weaving that otherwise
conforms to the tradition associated
with the Crystal Trading Post.
Kopp Collection

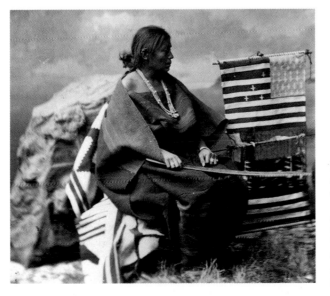

Figure 11. Juanita, wife of Navajo
Chief Manuelito, c. 1873
William Henry Jackson

*Jackson recorded the earliest known image
of the American flag on a Navajo flag
weaving. Juanita displays a flag rug that
is still on the loom. She has used crosses for
stars, and several crosses have spilled over
into the stripes.*

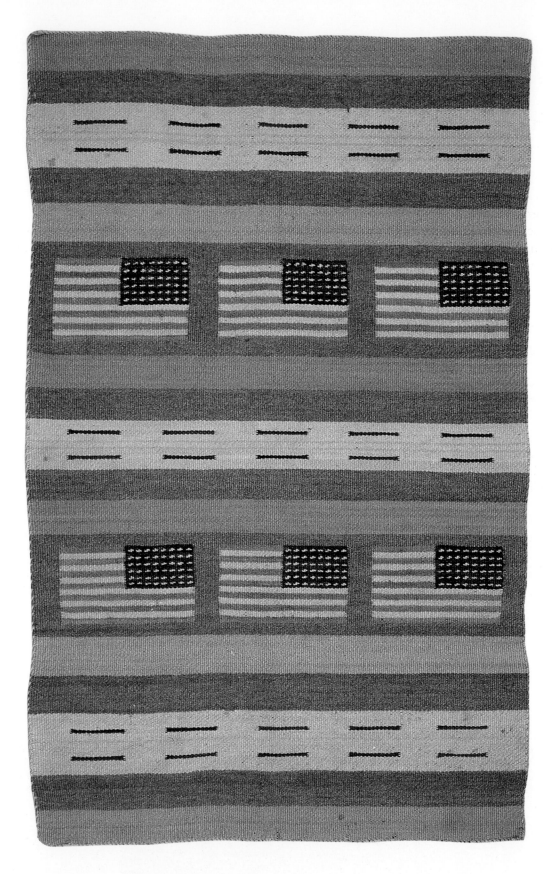

108.

RUG
Navajo
Circa 1930-1940
Handspun wool.
h. 44"; w. 26"

Rugs woven in the Chinle area of Arizona are distinguished by their subtlety and palette of soft colors. The subdued background of this rug contrasts the intensity of the six identical American flags.
Thaw Collection

WARRIOR TRADITION

THE PRINCIPAL MALE ROLE in Plains culture was that of warrior, the person responsible for protecting the people and the land. The nineteenth century brought profound changes: treaties with the U.S. government ended local raids and warfare; settlers staked out property for towns and ranches, mining and other businesses; the creation of reservations greatly reduced land areas and restricted hunting; and the buffalo was all but eliminated. Under these conditions, the culture and traditions of Plains Indian men was also forced to change. The last generation that experienced the pre-reservation period preserved into the twentieth century the old traditions in dress and ceremony, but later generations could only recreate the warrior tradition in ritual. To gain actual experience of the warrior's life, many Native Americans joined the U.S. military, especially during major wars.

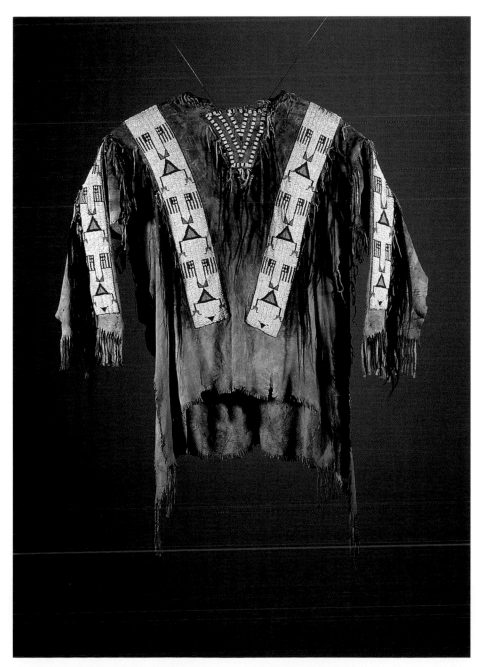

109.

SHIRT
Lakota
Circa 1890
Native tanned deerskin, paint, hair, porcupine quills, glass beads.
h. 34 3/4"; w. at shoulders 20"

The bluish-green and yellow pigment and locks of hair signify that the original owner was a "Shirt Wearer," a tribal leader who governed in the name of and according to the wishes of the tribal council (Utley 1963: 9). Shirt Wearers enforce their authority through tribal soldiers or policemen who were members of the Akicita Society. Although these institutions were on the wane in the late nineteenth century because they were no longer necessary under the Reservation system (Wissler 1916: 62), the existence of a very similar shirt in the Bern Historical Museum (Si40/1) suggests that these institutions did not die out by the 1890s.

The Bern shirt has the same design concept with bluish-green pigments, hair locks, heavy fringing and American flags on the beaded strips (Maurer 1992: 236). Its original ownership is attributed to Red Tomahawk, a Yanktonai tribal policeman who shot Sitting Bull during an arrest on December 15, 1890 (Utley 1963: 159–160). Red Tomahawk was made captain of the tribal police in 1892, a position that fulfilled some of the same duties as the traditional Shirt Wearers. The use of American flags may reflect the sharing of power between the tribal council and the Reservation agent and U.S. government. It seems likely that the owner of the Thaw shirt held a position similar to that of Red Tomahawk.
Thaw Collection

110.

FEATHER HEADDRESS
Cheyenne
Circa 1890–1910
Felt, glass beads, decorative tape,
eagle feathers, cotton bunting, silk
ribbon, wool yarn and cloth, calico
h. 89"

A superb example in the tradition
of the Plains, this headdress with its
star bunting may have been made
for an individual who fought with
or against the U.S. Army, for
Fourth of July celebrations, or
possibly for Wild West shows.
Thaw Collection

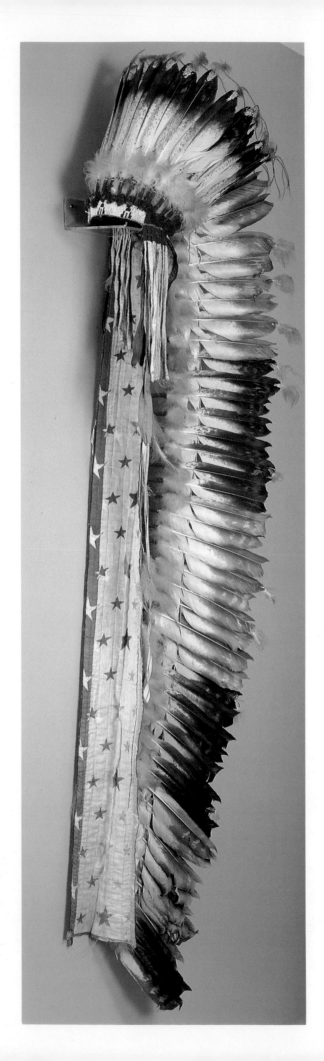

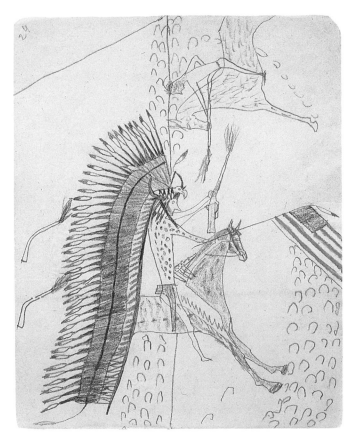

111.

LEDGER DRAWING
Lakota, attributed to Sitting Bull,
Oglala
Circa 1874
Paper, colored pencil.
h. 9 ½"; w. 7 ½"

This is one of thirty drawings
attributed to Sitting Bull, an Oglala
warrior who should not be confused
with Sitting Bull, the famous
Hunkpapa "Medicine Man." The
scene depicts an Indian warrior
holding a captured American flag as
a coup stick. In such use, the flag
became a source of personal power
and protection in battle.
Collected by Dr. J. J. Saville at the
Red Cloud Agency near Fort
Robinson, Nebraska.
Thaw Collection

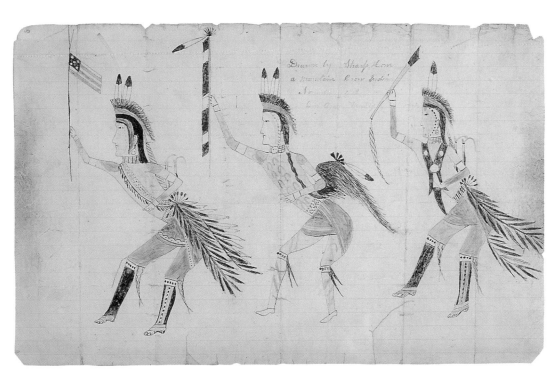

112.

LEDGER DRAWING
Inscribed "Drawn by Sharp Horn/ a
Mountain Crow Indian/ November
1883/ Crow Agency/ Montana
Territory"
Commercial lined paper, colored
pencil, ink.
h. 9 ⅝"; w. 15 ⅛"

American Indian cultures did not develop a
written language. History, particularly the
exploits of warriors, was passed down
orally or recorded through images carved
into rock; painted on hides, tipis, shirts,
shields, and robes; or recorded in quill and
beadwork on clothing and personal
possessions. In more recent times
American Indian artists have drawn on
paper or muslin.

The scene depicts three warriors

performing a "Grass Dance," a ritual started in
the early nineteenth century by the Omaha of
Nebraska as a war ceremony. It was adopted by
many of the Plains peoples and includes
elaborate dance bustles and individualistic and
free-form movements. Because the "Grass
Dance" is a warriors' dance, during the
Reservation Period it was probably believed
prudent to display the American flag as a sign
of allegiance and friendship.
Kopp Collection

113.
HOLSTER
Dakota
Circa 1890
Native tanned hide, glass and metal
beads.
h. 10"; w. 6 3/4"

The floral beadwork on this holster is
patterned after European needlework.
The thistle motif may derive from
insignia on Scottish trade goods.
Thaw Collection

114.
KNIFE SHEATH
Northern Style, possibly Rock Bay Cree or Yankton/
Santee Sioux of Devil's Lake Reservation, North
Dakota
Circa 1890
Parfleche liner, native tanned deerskin cover, glass and
metal beads, tin cones with red stroud.
h. 10 3/4"; w. 3 1/2"; Strap h. 3 3/4"

Like nineteenth-century folk artists, American Indian
craftspeople commonly reversed the image of the flag.
Thaw Collection

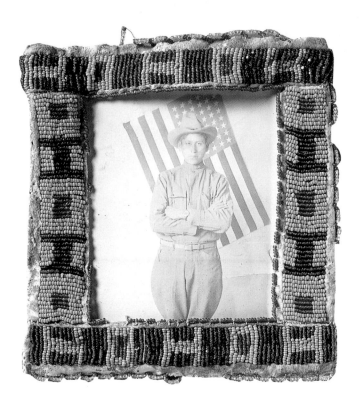

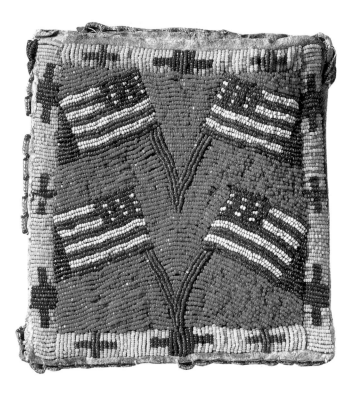

115.
CARTRIDGE BELT
Lakota
Late 19th century
Commercial leather belt, applied glass beads.
l. 45"; w. 3 1/2"

The belt is decorated with flags, four-directional crosses, and the letter "H." It is possible that it was made for a member of the tribal police force, an organization that was predisposed to side with the policies of the U.S. government.
Thaw Collection

116. TOP
PICTURE FRAME
Lakota
Early 20th century
Native tanned hide, cardboard, glass beads.
h. 5 1/2"; w. 4 1/2"

This picture frame is decorated with both round and faceted glass beads. The World War I–period photograph was collected separately.
Kopp Collection

117.
COMMEMORATIVE FLAG
1901
Cotton with hand-stenciled designs.
h. 44 1/2"; w. 81 1/2"

On June 25, 1901, a ceremony
dedicating a granite monument was
held in Montana at the site of the
Battle of the Little Big Horn and the
soldiers who died there. The surviving
Seventh Cavalry veterans and the
Indian scouts who served under
Custer were the honored guests. This
flag was presented to Chief White
Man Runs Him, a Crow scout, and
descended to his sister, Whinohna
Plenty Hoops, from whom it was
acquired in 1988.
Kopp Collection

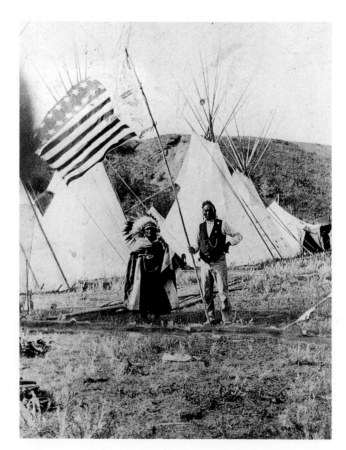

Figure 12. White Man Runs Him
and his wife, c. 1901–1905
Unknown photographer

White Man Runs Him holds the flag
that was presented to him on the twenty-
fifth anniversary of the Battle of the
Little Big Horn. His wife stands beside
him wearing his headdress.

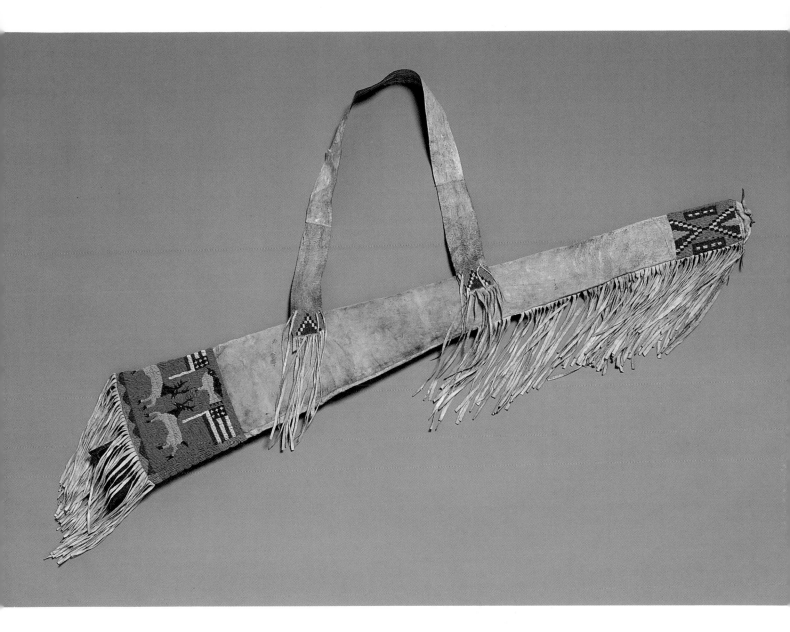

118.

RIFLE SCABBARD
Lakota, from the Flathead Trading
Post Collection
Circa 1890
Native tanned hide, glass beads.
l. (including fringe) 50"; w.
(including fringe and strap) 26"

Rifle scabbards serve as protection
from the elements. The muzzle end
of this scabbard has traditional
Lakota geometric beadwork, while
the stock end has pictorial images
of elk, flags, and a bird. While not
original to the scabbard, the
Winchester model 1873 rifle, one
of the most popular weapons on the
Plains at this time, fits the interior
space perfectly.
Kopp Collection

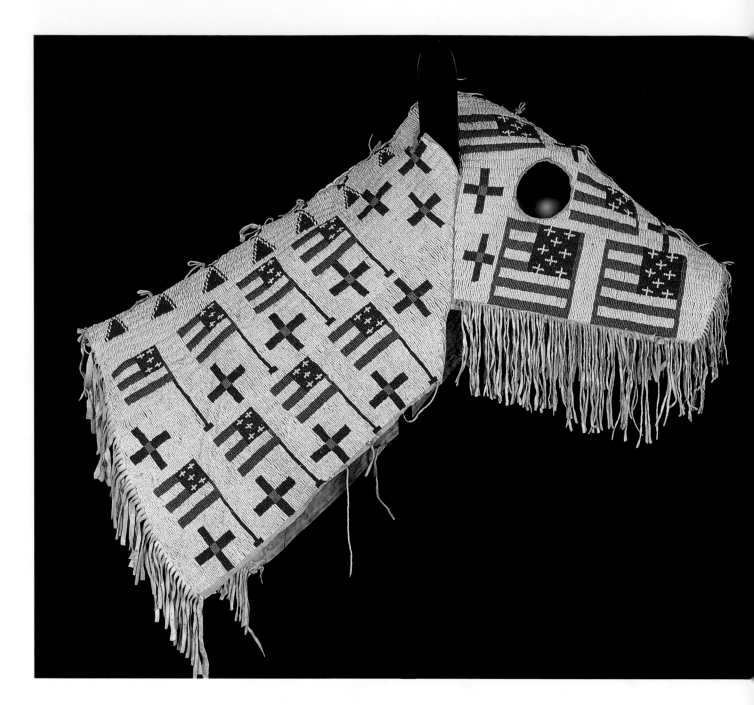

119.

HORSE MASK
Lakota
Late 19th to early 20th century
Native tanned hide, glass beads.
h. 28 1/2"; l. 35"

Horse masks add a spectacular, even
surreal quality to the horse and at one
time probably had ritual connotations
(Feder:1982, 114). By the late
nineteenth century, masks of this type
appear to have been used for Fourth
of July parades, though it is not
known if they honored specific horses,
portrayed the owner's wealth or
represented religious concepts.
Thaw Collection

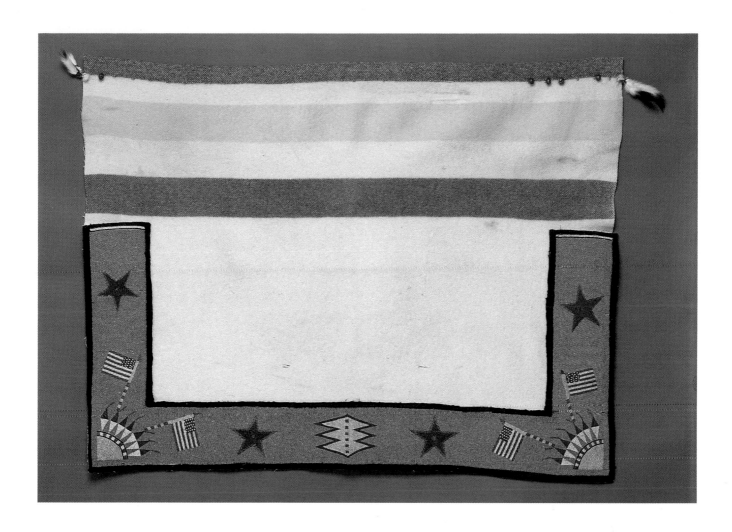

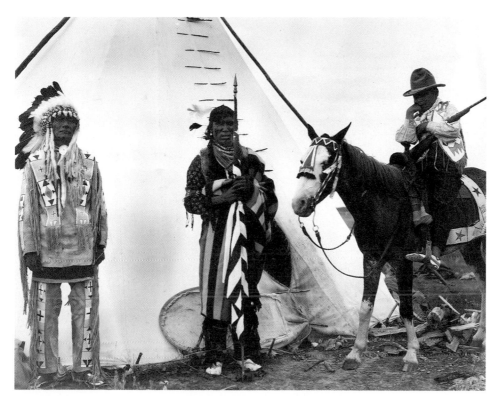

120.
SADDLE BLANKET
Gros Ventre or Assiniboine, Fort
Belknap, Montana
Before 1905
Commercial wool blanket, canvas,
glass beads, brass bells, ermine tails.
l. 31 1/4"; w. 40 1/2"

The feathered sun, or shield, motif
embroidered in the corners is a well-
established Plains symbol that is
found on early nineteenth-century
buffalo robes.
Kopp Collection

Figure 13. Fort Belknap Indian
Reservation, Montana, July, 1905
Sumner W. Matteson

*The Kopp saddle blanket is depicted on
the horse in this photograph of a Fourth
of July celebration. The American flag
can also be seen on the boy's vest and on
the flag staff.*

ROW IN LOVING MEMORY

121.

PAINTED HIDE
Shoshone, Wind River Reservation, Wyoming
Inscribed "DEDICATED TO UNCLE WASHAKEE FROM NEPHEWS ISAAC. THEODORE & WOODROW IN LOVING MEMORY"
Early twentieth century

Beginning about 1880, Washakie, the famous Shoshone leader from the 1850s to 1900, painted a series of elkskins with his son Charlie. The subject matter was traditional American Indian life, and the composition usually included a ceremony in the center with a buffalo hunt around the borders. The earliest images record the

Sun Dance, or summer thanksgiving ceremony. The hides painted after this dance was banned by federal authorities depict warrior dancers focused around the American flag, probably Fourth of July celebrations as seen here in a memorial hide painted by Washakie's nephews.
Thaw Collection

BIBLIOGRAPHY

Blish, Helen H. *A Pictographic History of the Oglala Sioux.* Lincoln: University of Nebraska Press, 1967.

Campbell, Tyrone, and Kate and Joel Kopp. *Navaho Pictorial Weaving, 1880–1950.* New York: Dutton Studio Books, 1991.

Conn, Richard. *Native Art in the Denver Art Museum.* Denver and Seattle: Denver Art Museum in association with University of Washington Press, 1979.

————. *A Persistent Vision, Art of the Reservation Days.* Denver: Denver Art Museum, 1986.

Crothers, David D. *Flags of American History.* Maplewood, NJ: C.S. Hammond & Co., 1962.

Duncan, Kate C. *Northern Athapaskan Art, A Beadwork Tradition.* Seattle and London: University of Washington Press, 1989.

Dyck, Paul. *Brulé: The Sioux People of the Rosebud.* Flagstaff: Northland Press, 1971.

Eder, Jeanne. "Massacre at Wounded Knee, 1890: Descendants of Indian Survivors Speak." In *Wounded Knee Lest We Forget,* 38–52. Cody, WY: Buffalo Bill Historical Center, 1990.

Feder, Norman. *American Indian Art.* New York: Harrison House/Harry N. Abrams, Inc., 1982.

Gogol, J.M. "Cornhusk Bags and Hats of the Columbia Plateau Indians," *American Indian Basketry Magazine* 1, no.2 (1980).

Grinnell, George Bird. *The Fighting Cheyennes.* Norman: University of Oklahoma Press, 1915; 8th printing, 1985.

————. *The Indians of To-Day.* Chicago and NY: Herbert S. Stone, 1904.

Hail, Barbara A., and Kate C. Duncan. *Out of the North: The Subarctic Collection of the Haffenreffer Museum of Anthropology, Brown University.* Bristol, RI: Haffenreffer Museum of Anthropology, Brown University, 1989.

Hail, Barbara A. *Hau Kola! Studies in Anthropology and Material Culture,* vol. 3. Bristol, RI: Haffenreffer Museum of Anthropology, Brown University, 1980.

Hamilton, Henry W., and Jean Tyree Hamilton. *The Sioux of the Rosebud: A History in Pictures.* Norman: University of Oklahoma Press, 1971.

Hassrick, Royal B. *The Sioux: Life and Customs of a Warrior Society.* Norman: University of Oklahoma Press, 1964.

Hyde, George E. *A Sioux Chronicle.* Norman: University of Oklahoma Press, 1956.

Lincoln, Louise. "The Social Construction of Plains Art, 1875–1915." In Maurer 1992, 47–61.

Mastai, Boleslaw and Marie-Louise. *The Stars and Stripes.* New York: Alfred A. Knopf, 1973.

Maurer, Evan M. *Visions of the People: A Pictorial History of Plains Indian Life.* Minneapolis: The Minneapolis Institute of Arts, 1992.

Mooney, James. *The Ghost Dance Religion and the Sioux Outbreak of 1890.* Chicago and London: The University of Chicago Press, 1965.

Pohrt, Richard A. *The American Indian, the American Flag.* Flint, MI: Flint Institute of Arts, 1975.

Porsche, Audrey. *Yuto'keca: Transitions, The Burdick Collection.* Bismarck: State Historical Society of North Dakota, 1987.

Powers, William K. *Oglala Religion.* Lincoln and London: University of Nebraska Press, 1975.

————. *Sacred Language.* Norman: University of Oklahoma Press, 1986.

————. *War Dance: Plains Indian Musical Performances.* Tucson: The University of Arizona Press, 1990.

Quaife, Milo M., F. Melvin Weig, and Roy E. Appleman. *The History of the United States Flag.* New York: Harper & Brothers Publishers, 1961.

Smith, Whitney. *The Flag Book of the United States.* New York: William Morrow, 1970.

Utley, Robert M. *The Indian Frontier of the American West 1846–1890.* Albuquerque: University of New Mexico Press, 1984.

————. *The Last Days of the Sioux Nation.* New Haven: Yale University Press, 1963.

Wade, Edwin L., ed. *The Arts of the North American Indian: Native Traditions in Evolution.* New York and Tulsa: Hudson Hills Press in association with Philbrook Art Center, 1986.

Walker, James R. *Lakota Belief and Ritual,* edited by Raymond J. DeMallie and Elaine A. Jahner. Lincoln and London: University of Nebraska Press in cooperation with Colorado Historical Society, 1980.

————. "The Sun Dance and Other Ceremonies of the Oglala Division of the Teton Dakota." In *Anthropological Papers of the American Museum of Natural History,* vol. 16, part II, pp. 55–219, 1917.

Wissler, Clark. "Societies and Ceremonial Associations in the Oglala Division of the Teton Dakota." In *Anthropological Papers of the American Museum of Natural History,* vol. 11, pp.1–101, 1916.

Wooley, David, and William T. Waters. "Waw-no-she's Dance," *American Indian Art Magazine* 14, no.1 (Winter 1988): 36–46.